texture techniques for winning watercolors

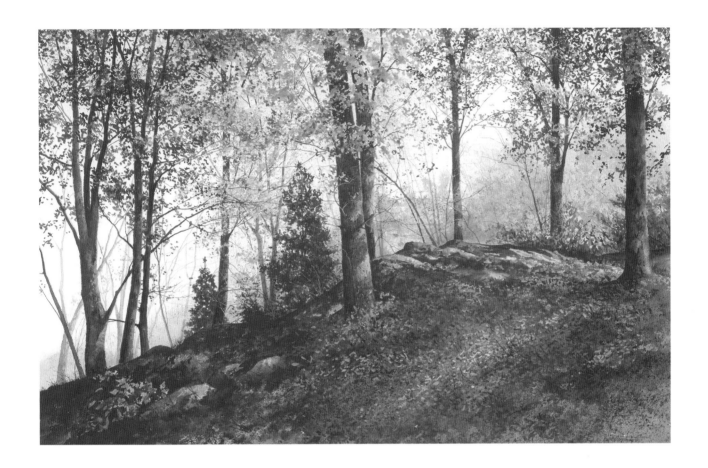

texture techniques for winning watercolors | Ray Hendershot

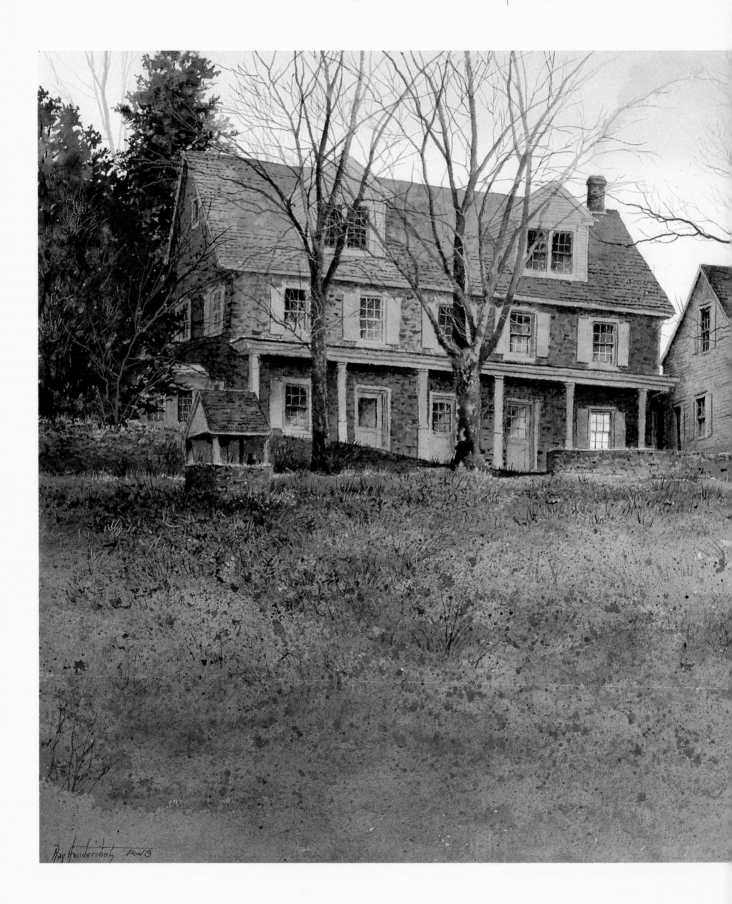

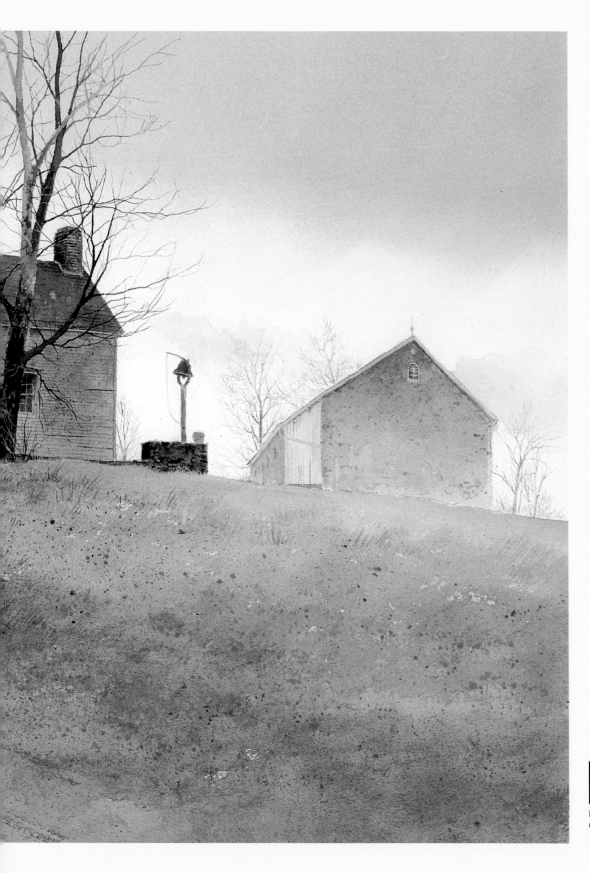

NORTH LIGHT BOOKS
CINCINNATI, OHIO
www.nlbooks.com

DEDICATION

I dedicate this book to my wife, Joan, who has exhibited Job-like patience over these many years in tolerating the erratic temperament of the artist and, more recently, of the author. This one's for you, kid.

And to my sons, Brad and Doug, for their encouragement and support throughout this endeavor.

ACKNOWLEDGMENTS

To my mother and dad, God rest their souls, who provided the environment for my early efforts as an artist. I only wish they were here to experience, with me, the rewards of those efforts.

To Rachel Wolf, who was my first contact at North Light Books and through whose efforts I was given the opportunity to achieve one of my lifetime artistic goals.

To Joyce Dolan, Nicole Klungle and Marilyn Daiker, my patient and extremely helpful editors, as well as all the other good people at North Light whose efforts transformed my thoughts into the beautiful book you are about to read.

To Mary Gardner, proprietor of the Golden Door Gallery in New Hope, Pennsylvania, whose support has significantly advanced my art career.

To my friends at the Pro Slide Shop in Landsdale, Pennsylvania, whose photographic expertise helped me over the rough spots.

To the numerous fellow artists and friends I have met throughout my painting career. It's been a wonderful experience.

Texture Techniques for Winning Watercolors. Copyright © 1999 by Ray Hendershot. Manufactured in China. All rights reserved. No part of this book may be reproduced in any form or by any electronic or mechanical means including information storage and retrieval systems without permission in writing from the publisher, except by a reviewer, who may quote brief passages in a review. Published by North Light Books, an imprint of F&W Publications, Inc., 1507 Dana Avenue, Cincinnati, Ohio 45207. (800) 289-0963. First edition.

Other fine North Light Books are available from your local bookstore, art supply store or direct from the publisher.

03 02 01 00 99 5 4 3 2 1

Library of Congress Cataloging-in-Publication Data

Hendershot, Ray
 Texture techniques for winning watercolors / by Ray Hendershot.
 p. cm.
 Includes index.
 ISBN 0-89134-892-1 (hardcover : alk. paper)
 1. Watercolor painting—Technique. 2. Texture (Art)—Technique. I. Title.
ND2420.H47 1999
751.42'2—dc21 99-25306

 CIP

Editor: Joyce Dolan
Production editors: Nicole Klungle and Marilyn Daiker
Production coordinator: John Peavler
Designer: Brian Roeth

Art on page 1: *Up in the Woods*, 19½″×29½″ (50cm×75cm), watercolor
Art on pages 2-3: *Bucks County Evening*, 17½″×29″ (44cm×74cm), watercolor

ABOUT THE AUTHOR

Ray Hendershot A.W.S., P.W.S., P.W.C.C., N.A.P.A.

Ray Hendershot has been producing artwork in one form or another for the better part of his life. For some time, however, this work had to play second fiddle to his primary career in the ceramics industry where he held various positions, including engineering manager of new product development and senior principal scientist for American Olean Tile Company. During these years, Ray spent as much time as possible working on his art techniques and developing a painting style. Through participation in local art fairs and exhibitions, he was able to build a reputation and a demand for his work.

It wasn't until his retirement in 1991, however, that Ray was able to put his artwork first and achieve greater exposure through national and international exhibitions and competitions. Since that time he has achieved numerous accomplishments, including signature membership status in the American Watercolor Society, the Pennsylvania Watercolor Society (where he is also a member of the Sylvan Grouse Guild), the Philadelphia Water Color Club and the National Acrylic Painters Association, which is home based in Birmingham, England. He was selected to be in the top one hundred of the National Parks' "Arts for the Parks" competition and was a finalist in the floral painting competition for *Artist Magazine*.

His paintings have been reproduced in two North Light books—*Splash 3* and *Splash 4*—which feature contemporary American watercolorists. Ray was also a featured cover artist in *Palette Talk Magazine*. He has had many successful solo gallery shows and has had work reproduced as limited edition prints.

Ray and his wife, Joan, presently reside and maintain a studio in Pennsburg, Pennsylvania.

TABLE OF CONTENTS

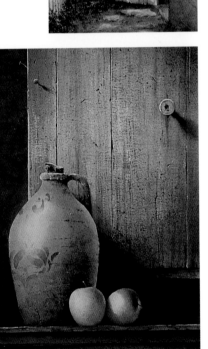

CHAPTER *one*
Let's Get Started *12*

CHAPTER *two*
Create Textures *24*

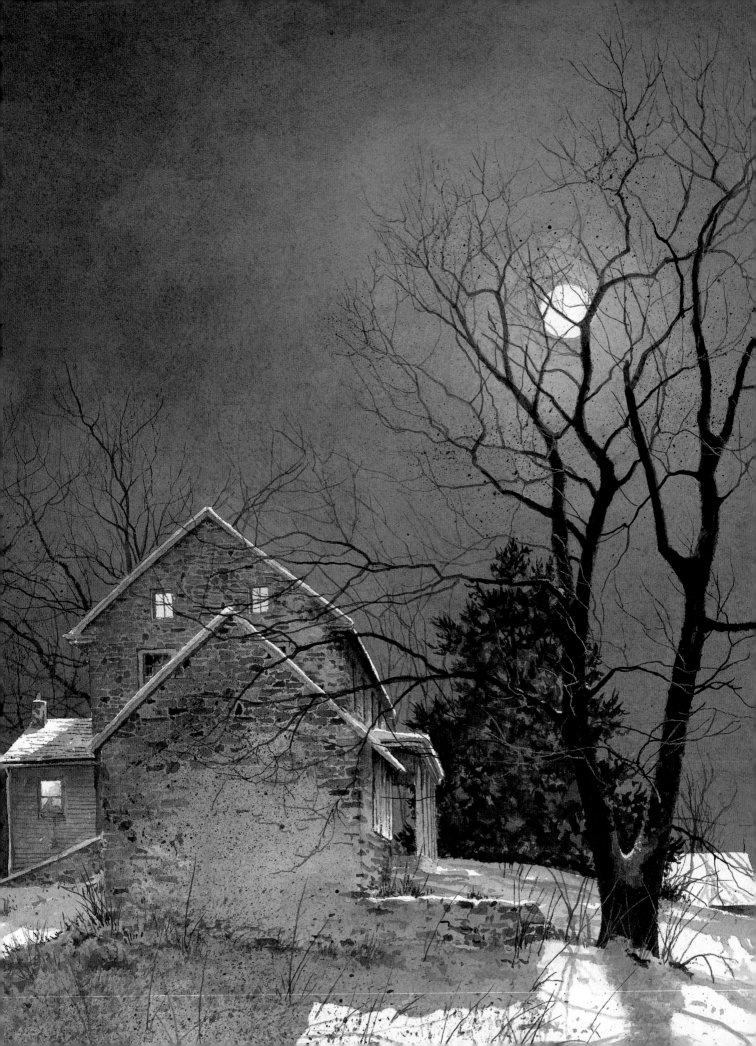

If it's true that a picture is worth a thousand words, then I probably already have spoken a few million words in my lifetime of painting. But much still remains to be said, for after over forty years of painting and exhibiting, I still consider myself to be a learner.

The bookshelves in my studio are lined with books on painting: art history, artists' biographies, exhibition catalogs of some of my favorite contemporary painters and, most importantly, art instructional books (particularly on watercolor painting). These books contain a wide range of philosophies, techniques and approaches to painting. Wide ranged as they are, they still have one thing in common: I have been able to learn something from each and every one of them that I could use to improve my painting or, at the very least, to get my creative juices flowing. Therefore, when offered the opportunity to write this book and pass on some of my own experiences in the hope of helping other painters, I jumped at the chance.

As a painter, I consider myself to be a realist. I do not, however, busy myself with the painting of each and every detail. I leave that to the photo-realists, whom I admire for their expertise and tenacity. However, I prefer to use a more painterly approach by expressing details through a variety of texturing techniques that in themselves are not totally realistic, but when viewed in the finished painting, are very convincing indeed.

I spent the better part of my early painting career as an oil painter. As you read on, you will discover that many of my texturing techniques require the type of bristle brushes used in oil painting. When I gave up the oil media for the watercolors, which I consider to be more rewarding, I brought along a few of my oil painting tools and techniques. In many cases, I find that the bristle brushes are able to produce textural effects superior to those produced by the softer and definitely more expensive watercolor sables. You will also find I am not a watercolor purist. I use opaques and other mixed media to create details and highlights. This emphasizes the transparency of the areas around them and creates a depth and dimension otherwise unachievable.

I am largely a self-taught watercolorist, so my approach to the media has been uninhibited by the accepted rules of the game. I have formed my own opinions and have formulated my own techniques through the method of trial and error. I hesitate to use the word *error*, for I do not believe in failure. With regard to my painting, I have always lived by the philosophy that I do not have bad experiences, I only have good and not-so-good experiences. I thoroughly believe that one can learn from every experience, even if the only lesson learned is what not to do the next time. So approach your painting with a positive attitude. God has seen fit to grant us a wonderful talent. Let's take advantage of it.

Working Late
18" × 13" (46cm × 33cm)
Watercolor

As active watercolorists, we are all familiar with the precept, "One of the most important things you can learn about painting is knowing when to stop." I submit to you that, for fear of overworking a painting, many learning artists tend to stop too soon, neglecting those extra little touches that can elevate an acceptable watercolor painting to the level of an outstanding watercolor painting. Those initial broad, fluid washes are still necessary as a base, but it is the textures worked into them that give the work its depth and life.

At this point, I feel I should offer a word of caution. You can have too much of a good thing. Creating texture can become addictive. Do not succumb to gimmickry, but use textures judiciously to emphasize a point or to direct the viewer's eye. You still need open areas to allow the viewer's eye to rest. It is the contrast between those open areas and the textured areas that creates interest.

This book is probably not for the beginning watercolorist. There are many good beginner books on the market (you probably already own as least one). Therefore, I will not describe basic watercolor procedures; my instructions will be geared towards the advanced beginner. I will make the following assumptions:

- You have some knowledge of the basics of watercolor and you have done some painting.
- You want information that will help you hone your skills and improve your work.
- You are willing to roll up your sleeves and paint along with me in order to learn the methods and techniques described in this book.

It is not my intention to change your way of painting. Nor do I expect to create an army of Ray Hendershot clones. The exercises within these pages are a result of my personal experiences of many years of painting. I hope I can pass on a technique, a bit of knowledge or some inspiration that will have a positive impact on your own unique style. I sincerely hope that you will continue to be yourself, doing the things that you do best, but, as a result of this book, will open yourself up to new ideas, new techniques and fresh approaches.

Stover-Myers Mill
20″ × 14½″ (51cm × 37cm)
Watercolor

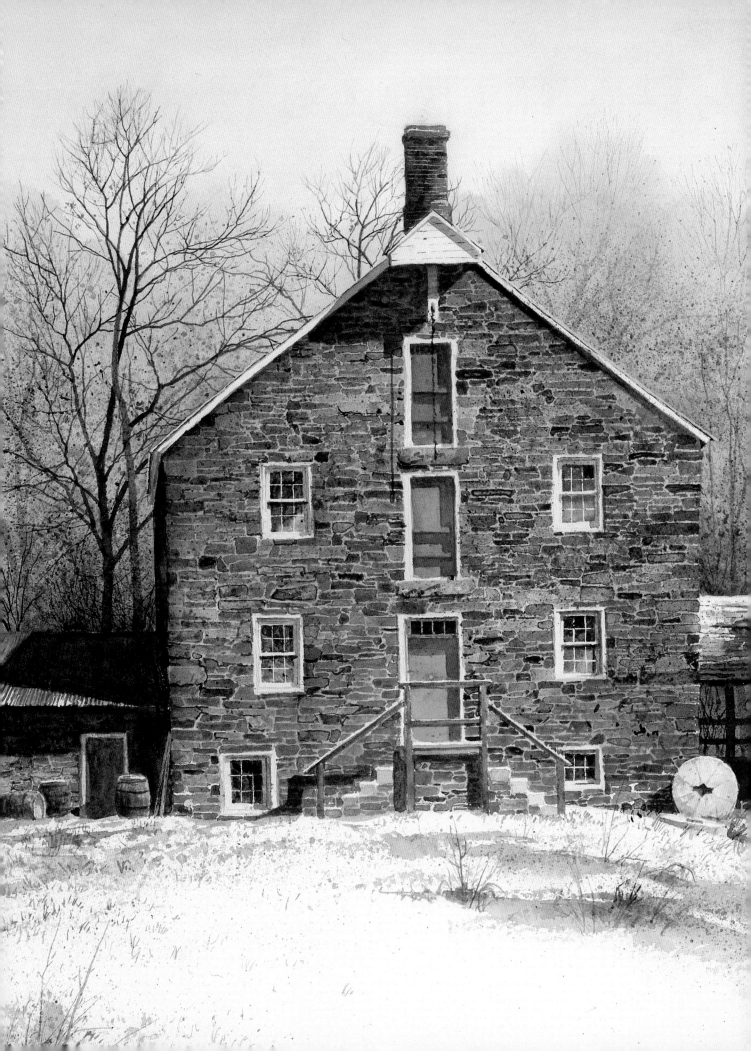

Let's Get Started

Let's take a look at the materials and tools needed to complete the exercises and demonstrations in this book. I won't delve deeply into the virtues or deficiencies of various products or brands. Those mentioned are *my* favorites, but others will work well, providing they're *professional quality* products. Don't skimp and buy student-grade papers and paints. The extra bucks you shell out are worth it with regard to performance and longevity of your work.

In watercolor painting there are countless ways to apply paint to paper, limited only by your ingenuity and willingness to experiment. This is particularly true when creating textures. In this chapter we'll put the tools and materials to work in a series of mini exercises. You'll learn application procedures and their results. I encourage you to paint along with me. Don't fret if your initial results don't match mine. Practice is the key. And feel free to experiment. I've included a few "Try this" suggestions at the end of several exercises to help you further explore the wonderful world of watercolor textures.

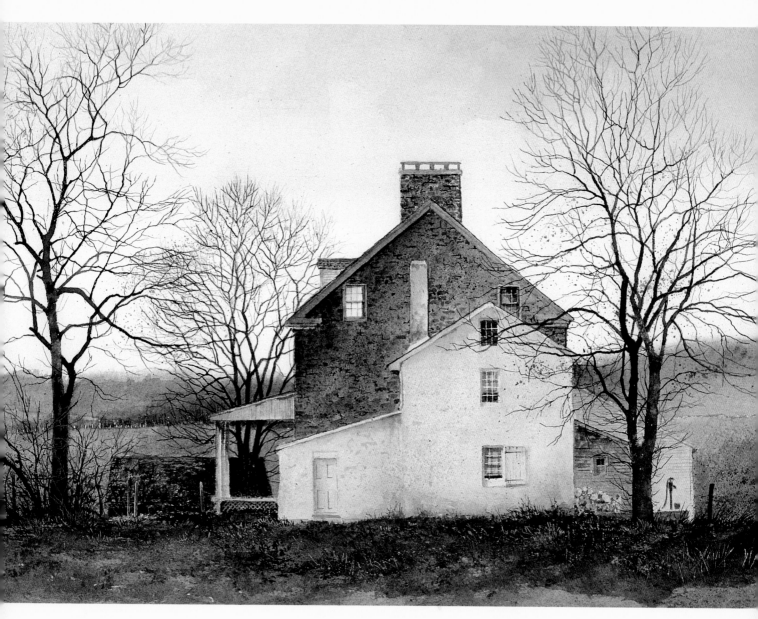

Retiring Early
14″ × 29¼″ (36cm × 74cm)
Watercolor

Materials and Tools

Paper

Watercolor papers come in various sizes, weights and surface textures and vary in qualities such as color and ability to absorb water. Each has its own personality and you must experiment until you find the one that suits your painting style and performs in a manner with which you are comfortable. I do hope, however, that your choice is a neutral pH, all-rag paper.

My favorite watercolor paper is 140 lb. (300gsm) or 300 lb. (638gsm) Arches in either the cold-pressed or rough surface. My decision on paper is based on the eventual size of the painting and the textures and effects I wish to achieve. The 140 lb. (300gsm) paper requires stretching to avoid eventual wrinkling, whereas the 300 lb. (638gsm) weight does not. Also, 300 lb. (638gsm) paper, because of its added bulk, has a tendency to stay moist longer, allowing for extended wet-in-wet working time. I find that Arches has a very tough surface that holds up well to my abusive techniques. All of the exercises and demonstrations in this book were done on this paper.

Paints

There are a number of fine professional-grade watercolors on the market. I use Winsor & Newton professional-grade, transparent watercolors in tubes because of their consistency, fineness and color intensity. I also like Holbein Acryla acrylic gouache because of its opacity and flatness. Both of these products perform to the best of my expectations. Again, you must make your own choice. You must be comfortable with and have confidence in the materials you use.

My transparent watercolor palette consists of:

- Sap Green
- Winsor Blue
- Cerulean Blue
- Cobalt Blue
- Alizarin Crimson
- Cadmium Red
- Cadmium Yellow
- Yellow Ochre
- Raw Sienna
- Burnt Sienna
- Raw Umber
- Warm Sepia
- Payne's Gray
- Neutral Tint
- with a few others thrown in on particular occasions

My acrylic/gouache colors are:

- Sepia
- Burnt Umber
- Burnt Sienna
- Yellow Ochre
- Naples Yellow
- Scarlet
- Orange
- Yellow
- Titanium White
- series of Neutral Grays, numbers one through four

I seldom use more than six to eight colors on any one painting. I feel this provides the color harmony I'm after. But color choice is a personal thing and, although I prefer a very subdued, limited palette, using brighter colors only selectively, you may choose to use a more colorful palette. Please feel free to do so when painting the exercises in this book. It will work equally well.

Recently I added a number of watercolor pencils to my paint array. They come in handy for the rendering of fine line work and for punching up an otherwise dull spot, particularly when you need lighter highlights in a darker area.

Brushes

Fine Kolinski sable brushes are the most commonly recommended brushes for painting in watercolor. It is true that their resiliency and ability to shape and hold a sharp point make them irreplaceable for soft wet-in-wet washes and fine detail work. I have my share of them and use them extensively in traditional watercolor techniques. I also use sable liner brushes in various sizes for fine line work.

This is one area in which I somewhat stray from the established, beaten path. The expense and fragility of sables inhibits their use for the more destructive texturing techniques. Here I prefer a hardier, more expendable brush. I find that bristle brushes commonly used in oil painting are quite sufficient for this purpose. They're not capable of holding a lot of water like their softer cousins, but I think you will be surprised at their versatility in drier applications. These brushes, with their coarser, stiffer bristles, are capable of pushing heavy applications of paint around when used in a scrubbing motion, producing effects unachievable with the softer-bristled brushes.

The Versatile Fan Brush

There's no brush in my toolbox that is more useful than the fan brush. I have several sizes in my brush arsenal, including a number that I've modified by cutting out (with a razor blade) intermittent areas of bristles, leaving what resembles a mod spike hairdo. I call these my "scary brushes." My scary brush family also includes a few round, soft, synthetic-haired brushes that I've modified for applying the small texturing strokes so frequently used in dry-brush work. To modify a brush, splay out the bristles and, while holding them in this position, apply a drop of acrylic medium to the base of the bristles at a point where they attach to the ferrule. Continue to hold in this position until dry and they will be permanently splayed.

Miscellaneous Brushes

I also have a number of stiff-bristled stencil brushes, in various sizes, that serve quite well when used in spritzing techniques and for scrubbing out and lifting dry-paint areas. For larger washes, such as sky work, I use squirrel-hair flat brushes in the 1-, 2- and 3-inch (2.5cm, 5.1cm and 7.6cm) sizes.

Last, but not least, I always have a few cheap synthetic-bristled brushes on hand for use in the application of liquid frisket.

Pens

Pens, of both the technical and crow quill type, are useful tools. Technical pens (Rapidograph numbers 3/0, 00 and 0), when loaded with fluid watercolor or ink, are great for rendering those fine detail lines. The crow quills come in handy when using more viscous materials, such as white acrylic or liquid frisket, that would tend to clog the fine tips on the technical pens.

Sponges

Consider purchasing a few natural sponges in varying textures. Dipped in liquid watercolor and used as a stamping tool, they can produce some very useful textures.

Masking

There are several ways to protect areas of your painting from the splashes and drips of adjacent paint applications. First is the standby, liquid frisket, sold in several brand names. I choose to use liquid frisket sparingly, merely outlining the areas to be protected, and then use masking tape, file cards or towels to shield the rest. The frisket is easier to remove after the adjacent painting is finished. Make sure the masking tape you use is a low-tack type commonly used for masking on drywall. If you use another type, you can remove some of the tack by presticking it to a piece of scrap paper before applying it to your work. This removes enough of the tack to make it manageable.

If you apply the frisket with a brush, make sure it's not one of your better ones, and take the precaution of wetting the brush with soap and water before dipping it into the frisket. It's easier to clean later. It's also a good idea, during extensive frisket applications, to frequently wash out the brush with water and reapply the soap solution before continuing. And absolutely do not allow the frisket to dry in your brush.

Make sure that the paper is completely dry before applying frisket or masking tape or you may eventually remove some of the paper along with the mask.

And while we are talking about masking, one item that's indispensable for shielding large areas from drips and splashes is a terry cloth towel. Have a couple on hand to use during your more sloppy moods. I find that file cards are also very handy for shielding smaller, irregularly shaped areas during spatter work.

Palette

I use a John Pike watercolor plastic palette for my transparent watercolors, but I switch to either a disposable paper palette or plastic-coated paper plates for the acrylics. Also, a muffin tin comes in handy for mixing those larger amounts of color necessary for big washes.

Techniques

Spatters, Splatters and Spritzes

I'm not sure that Webster clearly defines a difference between spatters and splatters, and I don't think that spritzes is even recognized as a word. But grammatically correct or not, this is my terminology for some of the methods of applying paint to paper in the creation of textures. Spatters, splatters and spritzes are similar in method but differ in the result. You're probably familiar with the method of flinging droplets of paint onto a surface by drawing your finger or a blade over the bristles of a toothbrush. This falls into my "spatter" category. I think the dot patterns produced by the toothbrush are too limited in size and pattern, so I've expanded my choice of brushes to include various bristle lengths and densities, each producing its own distinct pattern. Some might think I am splitting hairs on this one, but save judgment until you give it a try. At this point I'd like to extend a word of caution: When using any of these methods, take the time to cover anything in the immediate vicinity that you don't want to become polka-dotted (including your best shirt or blouse), as this can be a rather sloppy procedure. Having said that, let's go to the board and do a few trials.

Spattering

This is probably the most familiar of the texturing techniques. Use a medium-length bristle oil painting brush (about ¾ inch [2cm])—a no. 4 round is a good choice. Mix a puddle of dark color on your palette using a minimum amount of water. Load your brush with this color and, holding the brush parallel to the painting surface and about 2″ (5cm) away, slowly draw the blade of a painting knife toward you across the bristles. The resulting pattern is similar to one produced by the toothbrush method, but you have more control with this method. Spattering is a good technique for indicating roughness or giving life to an otherwise flat wash.

TRY THIS . . .

• **Vary the amount of water in your paint mix.**

• **Try other brushes, bristle lengths and densities.**

• **Vary the distance the brush is held from the painting surface.**

Reverse Spattering

This is the same technique as spattering, except you'll use liquid frisket instead of paint for your spatter work and when it's dry, follow it with a wash of color. Removing the frisket reveals the pattern. I've found this technique comes in handy when expressing vegetation such as grassy areas and tree or bush foliage.

TRY THIS . . .

• **Vary color combinations before and after reverse spattering.**

Spattering on Damp Paper

Use the same method as for reverse spattering, only this time dampen your paper first and wait until the sheen disappears before spattering. You'll immediately see small dots of paint spread out and fuse with the background in varying degrees depending on the initial size of the droplet and the amount of dampness in the paper.

TRY THIS . . .

• Vary the wetness of your paper before spattering.

• Hold the paper at a very slight incline after spattering to allow

 spots to run.

Directional Spattering

Hold the brush in the same manner but draw the palette knife on a line almost parallel with the plane of the paper. As a result, the droplets are sprayed from the brush at an oblique angle. When they strike the painting surface, they tend to form elongated spots that suggest movement. This technique comes in handy for applying white paint to simulate a driving snowstorm.

TRY THIS . . .

• Tilt the paper while spattering vertically to obtain a similar

 result.

Splattering

The distinction between the splatter and the spatter is the size and shape of the resulting application. A splatter is produced much the same way as a spatter but is followed by an additional splattering of water while the paint is still wet. This results in large, irregular-shaped blotches as the paint and water intermingle. Texturing with this method requires a bit more fluid paint than the spatter method. I often use the spatter and splatter methods together to create variety in my texture.

TRY THIS . . .

• **Try the water spatter before and after the paint spatter.**

• **Spatter water into a semidamp watercolor wash.**

• **Try water spatters on a nearly dried wash, blotting afterwards.**

Spritzing

Spritzing produces the finest dot, resembling a mist rather than a distinct dot pattern. I use this method to create mist or snowstorms. Use the stiffest and shortest bristle lengths. A stencil brush works well. I used a no. 4, which has a hair length of about ⅜ inch (1cm), for this example.

TRY THIS . . .

• **Dampen the paper before spritzing.**

• **Apply a light-colored spritz into a darker painted area.**

Salt

Achieve an interesting mottled effect by sprinkling ordinary table salt (or rock salt, for a more violent reaction) on a wet watercolor wash. Use a small amount of salt in this process. The salt granules sponge up the surrounding water and form crystalline shapes as the paper dries. You can stop the process by drying the wash quickly with your hair dryer. This technique works best with staining colors but will work to some degree with any color. The wetness of the surface greatly affects the result, so experiment to get the effect you want.

TRY THIS . . .

• **Vary the amount of salt and the surface wetness.**

• **Spatter the water after the salt application.**

• **Tilt your painting surface slightly as it is drying.**

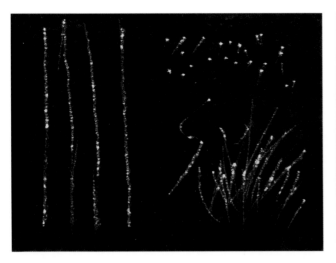

Scratching

Different tools can be used for scratching a mark into a painted surface, ranging from palette knives and fingernails to the non-business end of a paintbrush, depending on the effect you want. Scratching into wet paint results in a dark line. Scratching into a dry surface results in a light line because the paint doesn't flow back into the scratched area. Scratching with a blunt instrument into semiwet paint pushes the paint aside, exposing the subsurface. Use this technique to suggest light weeds or grasses in a darker field. Scratching with a sharp instrument on a completely dry surface picks out white highlights by exposing the paper underneath. I use this method to highlight the edges of cracks and holes, bringing them into dimensional relief. Be careful not to cut through the paper. Cautiously use the corner of a single-edged razor blade to scratch highlights.

TRY THIS . . .

• Scratch into painted areas of varying degrees of wetness.

• Vary the instrument used to scratch (sharp, blunt, edge of a
 piece of mat board, etc.).

Scraping

Scraping is done by drawing the flat side of a razor blade or other instrument over the painting surface. Again, the results depend on the wet or dry condition of the paper. Scraping on a wet painted surface pushes the paint away, exposing a lighter area that's fairly uniform in value. Use this method to indicate lighter tree trunks in an otherwise dark painted woods scene. Scraping on a dry painted surface results in a light/dark mottled texture. The light areas are determined by the high areas of the paper's surface texture, or tooth. For example, I frequently use the method to simulate the rough texture of wood.

TRY THIS . . .

• Vary the wet/dry condition of the painted surface.

• Try various scraping instruments (palette knife, mat board
 pieces, etc.).

• When scraping semiwet paint, hold your scraper at an angle,
 with one corner touching the paper and the other very slightly
 lifted; this results in a gradation from light to dark.

Painting and Blotting

Painting and blotting is an effective way to produce a mottled finish. Generally, a thicker, darker value of paint responds best to this process. I use this approach effectively for textures of rock or reflections in glass. Practice on small areas. Apply the paint and immediately blot the wet paint with a crumpled paper towel or tissue. This produces an uneven pattern of light against dark because of the irregularities and creases in the blotting material. Be sure to frequently change the section of paper towel or tissue you are using to blot to avoid printing paint back onto the surface and repeating the pattern.

drybrush

reverse drybrush

Dry-Brush Work

Drybrushing is a technique of applying a darker, broken pattern of texture over a dry painting surface. Use a bristle fan brush—a no. 6 is good. Load it with a sizable amount of a dark, fluid wash. Hold the flat of the brush on a plane that is almost horizontal to the paper, and pull it towards you, creating an interesting, broken pattern of lines and/or dots. The result depends on the surface texture of the paper and the fluidity of the paint in your brush. I use this method frequently to indicate the texture of wood surfaces. The first cousin of this technique is the reverse drybrush, in which the above method is used to apply liquid frisket. When it is dry, a color wash is applied on top. Removing the frisket reveals the dry-brush pattern in reverse.

TRY THIS . . .

• **Vary the paint fluidity.**

• **Try different angles of the brush to the paper.**

• **Try the drybrush on various paper textures.**

Drybrushing, "Scary" Brush Style

I use one of my homemade, soft-hair "scary" brushes for another interesting technique similar to the conventional drybrush method. You already may be familiar with the technique of picking up a load of paint in your brush, squeezing the bristles between your fingers to remove most of the moisture and splaying the bristles before each and every application. Why go to all the trouble? In the case of the scary brush, the bristles are permanently splayed, so the technique only involves picking up a not-too-wet load of paint and applying it with short, interrupted strokes.

Patting

This method, related to drybrushing, involves the use of a fan brush to actually stamp a mark or design. With a no. 2 bristle fan brush, pick up a load of semifluid paint. With the brush horizontal to the painting surface, move the flat of the brush in an up-and-down motion, touching the paper only once in any particular spot before moving on to an adjacent area, leaving behind an impression of the bristles of the fan brush. This technique is useful to indicate small branches in background tree masses and small twigs and underbrush in foreground vegetation.

General Fan Brush Techniques

It is possible to achieve a number of useful textures by varying the way you hold and move the fan brush (or "scary brush"). For example, hold the brush vertical to the painting surface and, with only the tips of the bristles touching the paper, stroke away from you with sweeping, lifting strokes to produce an effect resembling high grass or weeds. Holding the brush in the same manner, again with only the tips of the bristles touching the paper, pull the brush toward you, keeping your hand parallel to the painting surface. Now you've created wood grain or tree bark texture. Next, hold the brush at about a 45° angle and pull it toward you in short, jabbing strokes. Allow the flat of the brush to come in contact with the paper at the end of each stroke. This texture is useful for creating the top edge of a stand of trees (this method probably works best with a somewhat drier paint mix).

Sponging

A natural sponge is a useful tool for covering large areas with a stippled design that resembles tree foliage. Mix a puddle of a fairly light color in your palette. Touch the surface of the sponge to the puddle, and transfer the paint to the paper with a light stamping motion. Repeat, using different areas of the sponge to prevent design repetition. Vary your colors, beginning with a light value and becoming darker with subsequent stampings. Allow to dry between each series of stampings.

TRY THIS . . .

• **Use various types of sponges (some are coarse, others fine in**

 texture).

• **Use other materials for stamping.**

without acrylic medium with acrylic medium

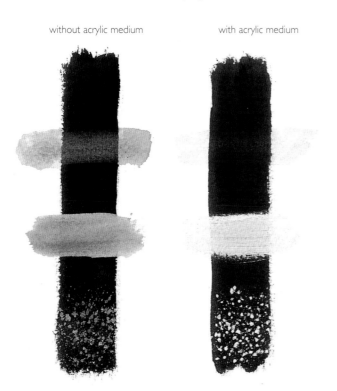

Scrubbing Out

Occasionally you'll need to place a light object into a previously painted dark area, such as a light tree trunk in a dark woods. Use a dampened, stiff-bristled stencil brush as a scrubber to loosen the paint film. Then blot with a paper tissue to remove the loosened pigment. For a sharp edge, mask off the targeted area with masking tape before scrubbing. For a softer transition, just scrub and blot. The success of this technique depends on the toughness of your paper. Softer papers may "pill." If so, stop, dry and repeat the process until you get the desired value.

Acrylic Medium

On rare occasions, if you anticipate an extraordinary amount of overworking on your initial wash, add a bit of acrylic matte medium to the wash. With this addition, the wash is better protected and is less likely to be picked up by subsequent work. You can't use this method if you need to scrub out later, however. I use this method when I expect to use a light application over a darker one, such as spattering a white snow over a dark background. Without the addition of acrylic medium, the dots of white may melt into the background. The amount of medium should be proportionate to the amount of water resistance you desire. For the toughest of jobs, use an amount of medium equal to the amount of paint squeezed from the tube. That's what I used for the example in the illustration. The strip on the left is untreated paint, while the one on the right has the acrylic addition. Note the difference between the two when scrubbing out with a bristle brush (top), painting over with white gouache (middle) and adding a spatter of white paint (bottom).

TRY THIS . . .

• **Experiment with various additions of acrylic medium. You may**

 find that a little is all you need to achieve the desired amount

 of water resistance for your application.

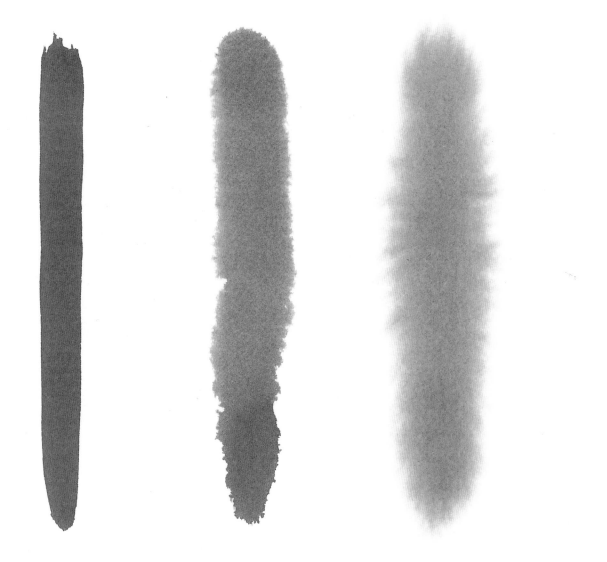

Dry vs. Wet Paper

Throughout the exercises in this book, I often refer to the wet condition of the paper before an application. The way paint flows from your brush and reacts when applied to the paper depends on how wet or dry the paper is. Paint that is applied to dry paper usually stays where you put it, retains most of its intensity after drying and forms a shape with nice, crisp, hard edges.

On the other hand, a paper that has been soaked and is still quite moist will act as a sponge, literally pulling the paint off your brush, sending it in all directions in an almost uncontrollable fashion. It dries to a much lighter intensity and will have soft, blurred edges. Of course, any wetness condition between these two extremes will react with varying degrees of control and appearance.

In this example, I tried to show what to expect from varying degrees of paper wetness while using the same paint consistency. The stroke on the left was painted on paper that was soaked and allowed to dry until the shine disappeared. The middle stroke was applied to paper that was still slightly damp (the paper looks dry, but is still cool to the touch). The stroke on the right was applied when the paper was completely dry.

You can see how the controllability was affected by the moisture in the paper.

Let me point out, however, that paint flow and its resulting effects are influenced by many other factors, including type of paper (weight, texture, amount of sizing); the amount of water-to-pigment ratio in your paint mix; and the addition of other ingredients, such as acrylic medium or watercolor flow enhancers (e.g., ox gall liquid). Of course, you have the luxury of stopping the paint flow at any time by using a hair dryer. There is no way to unequivocally determine the behavior of watercolor on wet paper without prior experimentation. So, get out your scrap paper and experiment, experiment, experiment.

TRY THIS . . .

• **Try different paper textures and paper weights.**

• **Vary the amount of water added to the paint mix.**

• **Try watercolor mediums designed to enhance flow.**

Create Textures

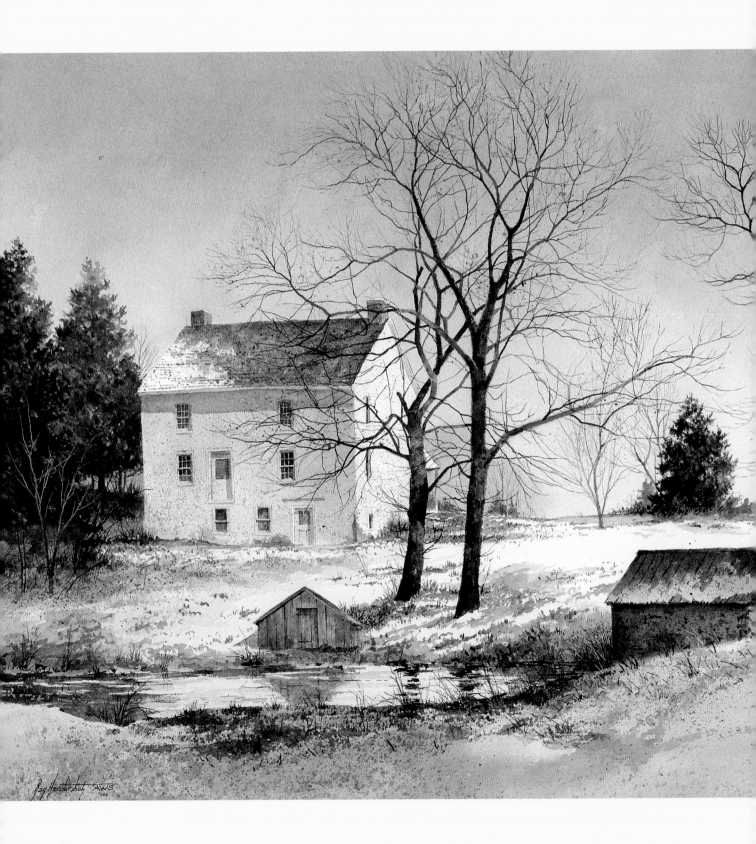

This chapter is dedicated to incorporating the texturing methods you've learned into actual painting situations by doing a series of step-by-step exercises. Here, I've used passages from some of my existing paintings to illustrate the application of those methods. Again, it is not important that you exactly duplicate the illustrated work, nor that you use the same colors. What is important is that you become involved. So pick up your brushes and let's get to work.

Frozen Reflections
14″×29½″ (36cm×75cm)
Watercolor

Tree Anatomy

If there's one area of detail that can have a large impact on the success of a landscape painting—but is many times neglected by artists—it's the area of tree anatomy. I've seen many otherwise excellent paintings compromised by poor, sketchy, understated depictions of tree structure. Each tree variety—deciduous or coniferous—has its own unique shape and structure. We won't get into a long dissertation on tree identification. More times than not, though, trees are a main element in a landscape composition and sometimes even serve as the focal point. So it's a good idea to pay attention to the structure of trees and learn more about their anatomy.

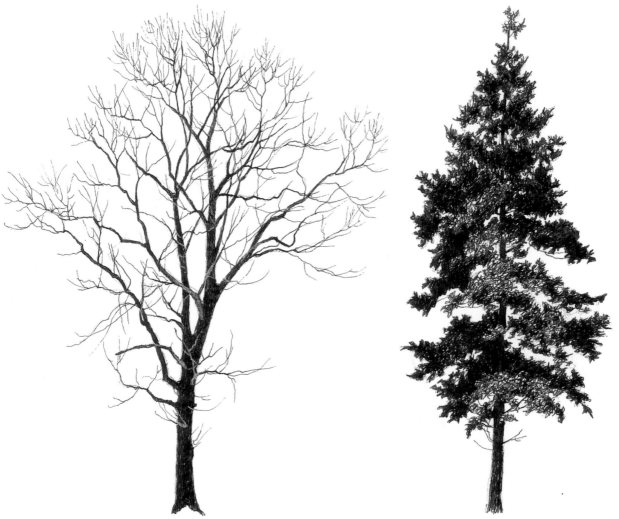

The best time to observe tree structure, at least that of the deciduous variety, is in the winter when the trees are devoid of their leafy clothing. Take a good look. Generally, trees don't stand straight and aren't perfectly symmetrical. They have branches that cross over one another and extend to the front, back and sides. The branches don't end with blunt, stubby tips, but continue to divide and subdivide into intricate networks of twigs that give the tree its real character. Paint them that way. Whether you paint the tree bare limbed or in full foliage, this structural knowledge will help you make your trees more believable.

Notice the structure of a coniferous tree. It's not exactly the symmetrical, Christmas-tree shape we often see in artwork. It's unsymmetrical; there are missing branches, different lengths of branches and branches that project forward from the mass of foliage.

Paint Background Trees

Many times the background of a painting is understated. It's often painted with nebulous, weak washes and little or no detail. You shouldn't include insignificant details that detract from the subject or focal point, but a well-painted background with just enough detail becomes the perfect foil for the rest of the painting. Such is the case with *Shades of Monday*.

Shades of Monday
18″ × 29″ (46cm × 74cm)
Watercolor

TECHNIQUES USED:
- Fan brush
- Spattering
- Patting

COLORS USED:
- Payne's Gray
- Raw Umber
- Warm Sepia
- Burnt Umber
- Acryla Burnt Sienna
- Acryla Yellow Ochre

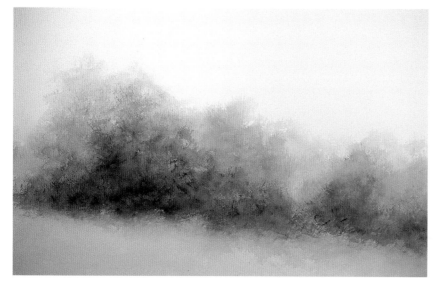

STEP 1
Paint the Initial Washes

Use your modified bristle fan brush (scary brush) to lay in the initial wash for the trees. Pull the brush down from the top so the bristles form fine branches at the top of the tree line. Intensify the value and vary the direction of your brushstrokes as you work downward. Don't be too careful at this stage; you don't want an even wash. Inconsistencies add to the effectiveness of the finished work. As the paper dries, continue to work in darker values, further defining the tree forms. Leave a ragged edge at the bottom and use a bit of water to soften the transition between the woods and the ground. Allow to dry.

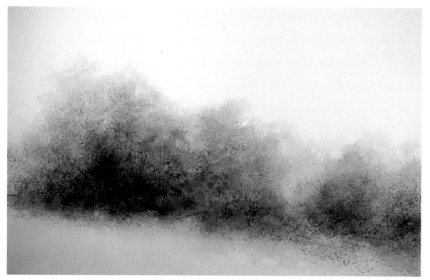

STEP 2
Define Leaf Masses

Splatter the lighter areas with a variety of coordinating colors. Follow this with splatters of clear water to form large, irregular patterns suggesting foliage or branch masses. This is a messy process, so make sure you use a towel to cover the freshly painted sky and the foreground area. I can't begin to tell you how many beautiful skies I've ruined by not taking the time to do this simple thing. Again, allow the application to dry.

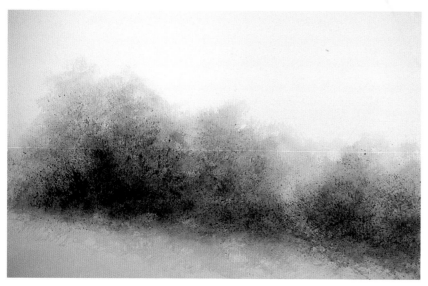

STEP 3
Add Leaf and Branch Shapes

Now use the spatter method, with a less-fluid mixture and a deeper value, to produce additional smaller and more distinct dots. Also add some darker values to create shadows at the base of the trees. Now, pick up a very dark, thick mixture with the fan brush and, using the flat of the brush in a patting motion, apply irregular shapes. The resulting shapes will again be suggestive of radiating branches. Allow to dry.

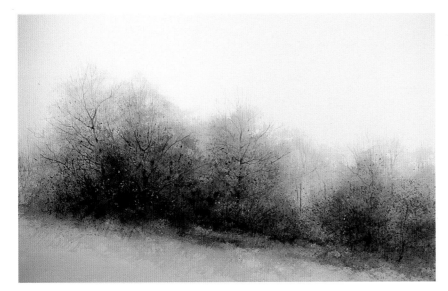

Paint the Trunks and Limbs

Now it's time to bring it all together. Using a sharply pointed round sable brush, paint the branches and tree trunks. Don't paint the entire tree. Leave skips here and there to indicate the presence of limbs and/or foliage in front of the tree. Use the darkest value on the tree trunk, getting progressively lighter as you work toward the branches farthest from the trunk. Finish by painting a few lighter-colored dots with gouache to suggest occasional brighter leaves. Don't overdo this. Just a few well-placed highlights, especially in the darker areas, will give an added punch. Hopefully, at this point your efforts will be rewarded by a realistic, yet painterly rendition of a background wooded area.

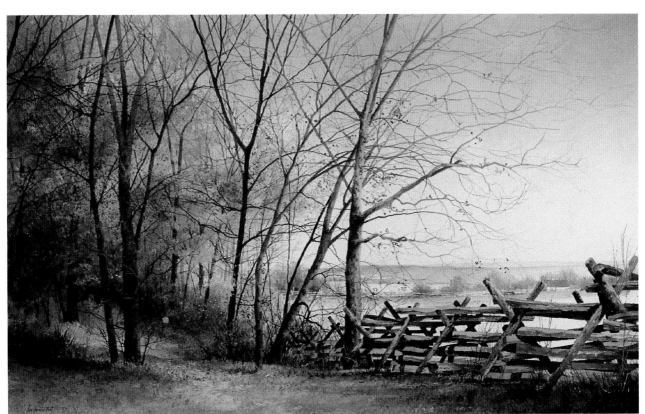

Another Example

The same techniques were used to paint the trees in *Split Rail*, but in this painting the tree grouping pushes forward and becomes a prominent part of the composition. Thus, the texturing becomes even more important.

Split Rail
18″ × 29½″ (46cm × 75cm)
Watercolor

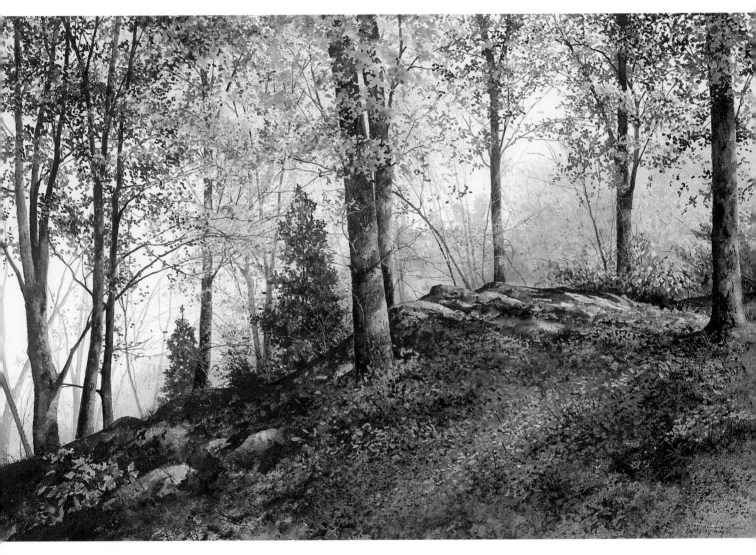

In the fall, my wife and I often take walks in the county park near our home. As we admire the brilliance of the autumn colors and the way the light filters through the foliage, casting irregular shadows on the already fallen and dried leaves, we are in awe of Mother Nature's creativity. We'll use the backlit wooded area in *Up in the Woods* for this exercise in how to paint fully foliated trees.

Up in the Woods
19½" × 29½" (50cm × 75cm)
Watercolor

TECHNIQUES USED:

- Patting
- Spattering
- Splattering
- Fan Brush

COLORS USED:

- Cadmium Yellow
- Yellow Ochre
- Raw Sienna
- Raw Umber
- Burnt Sienna
- Burnt Umber
- Warm Sepia
- Sap Green
- Winsor Blue
- Payne's Gray

STEP 1

Paint the Background Colors

All you need to begin this exercise is a sketchy drawing; we'll compose this exercise as we go. Draw only enough to indicate the placement of the major objects. No masking is necessary. The background should be painted loosely, with the colors blending and fusing together to indicate distance. Dampen the background area with water, and randomly brush in a yellow wash, leaving some openings for "sky holes." Float in pale, grayed colors to indicate the distant tree line. Some of the colors blend at this point due to the dampness of the paper. As the paper dries, your brush marks become more distinct, so continue to define the tree shapes with your fan brush. Add a few tree branches and some matching color spatters (same as the colors used above) here and there.

STEP 2

Define Leaf Masses

When the paper is completely dry, do some patting work with the fan brush, further emphasizing the leaf shapes on the background trees. Then rough in some foliage masses on the dominant foreground trees, varying your colors and values. Begin with the lightest values and overlap the darker values as you work toward the front of the painting. Here, we only want to establish the positions of the major masses of leaves. Add the dark value in front to define the ground plane.

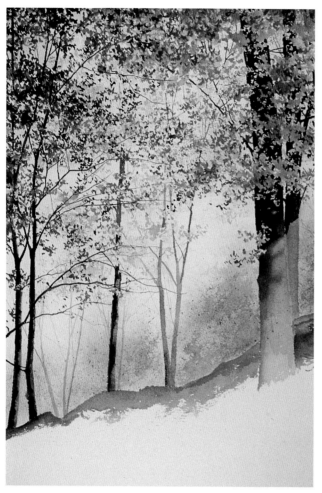 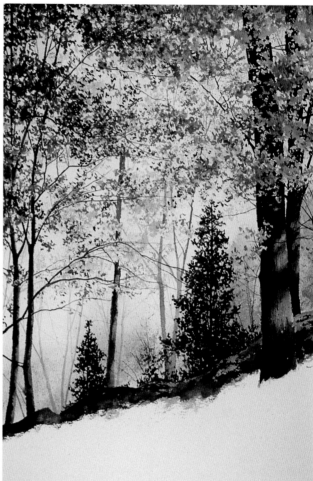

STEP 3

Paint the Branches and Trunks

Now paint the dark trunks and branches of the trees. Leave lighter patches on the lower trunks to indicate sunlit areas. Paint around some of the leaf shapes to define those that project to the front of the trunks. Also, put in some distant tree trunks and branches with a slightly grayed, less intense value.

STEP 4

Add Leaves, Trees, Underbrush and Rocks

Continue to add and refine the leaves by adding single strokes in an almost pointillistic fashion, again varying your colors and intensities. Finish by painting the two coniferous trees as well as the dark underbrush and rock shapes almost as silhouettes, further emphasizing the very dramatic effect of backlighting.

exercise | Fully Foliated Trees, Sponging Method

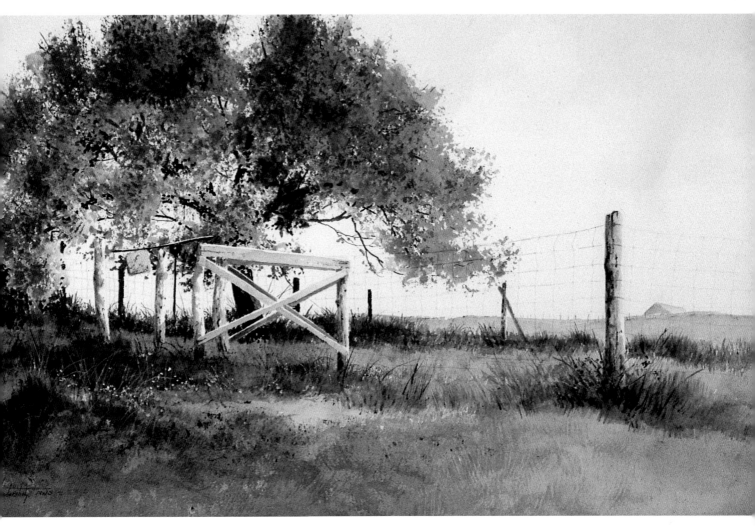

Another effective way to paint trees or bushes in full leaf, particularly when larger, more dense leaf masses are required, is to use a sponging technique. Natural sea sponges work best because of their irregularities, although some interesting textures can be achieved with man-made sponges, as well. Tear off a small, irregular piece, wad it up and begin stamping. To prevent pattern repetition, frequently change direction and rotate the sponge.

Study for *North Corner*
12½″ × 21½″ (32cm × 55cm)
Watercolor

TECHNIQUES USED:
• Sponging

COLORS USED:
• Raw Sienna
• Hooker's Green
• Burnt Umber
• Sepia

Sponge in Leaf Masses

Begin with a loose sketch of a tree shape. Prepare a puddle of light green in your palette. Try a mix of Hooker's Green and Raw Sienna and neutralize it with a bit of Burnt Umber. Don't use too much water. This method requires a fairly dense paint. Begin sponging. Add a number of leaf mass groupings, following the shape of the tree. Leave some open areas to keep your tree airy. The trick here is to pick up a lot of color (one trip to the palette is probably good for three or four stampings before reloading) and to use a very light stamping motion so the natural texture of the sponge is transferred to the paper. Allow sufficient drying time before overstamping. If you stamp too zealously or work too wet, you'll end up with a multitude of ugly, shapeless blobs instead of the suggestion of individual leaves. Allow to dry.

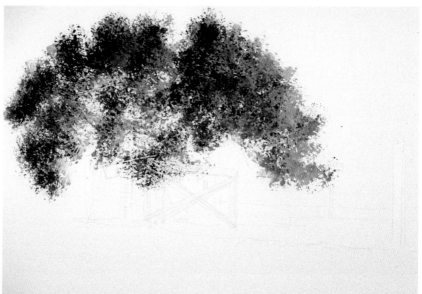

STEP 2

Give Dimension to Leaf Masses

Now prepare a middle-value green (no Raw Sienna, add more Burnt Umber). Continue stamping with this mix, favoring the shadow sides of the leaf masses (in this case the left side and underneath). This gives dimension and form to the leaf masses by adding shadows. Much of the first application from step 1 is covered during this step, but enough shows through to be effective.

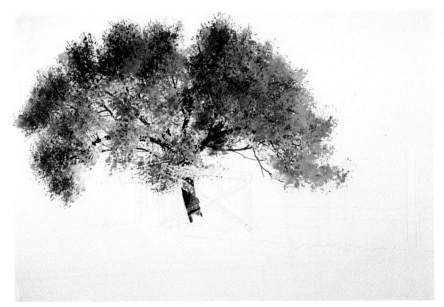

Define Tree Trunks and Branches

These are most visible in less leafy areas. They are also visible in some of the darker areas, pushing those areas back where they define the leaves on the far side of the tree. Make sure to outline some of the leaf shapes, which projects them forward. Notice how the shapes of the leaf masses become more defined and dimensional. Allow to dry.

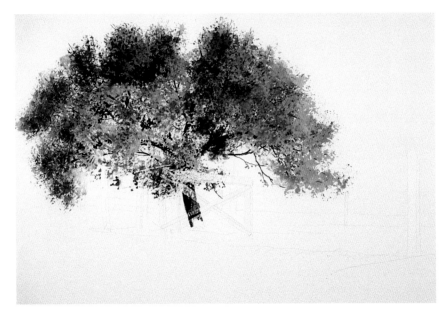

Finishing Touches on the Trees

After the leaf masses are well-defined, do a little brush work to put the finishing touches on the tree. Use your deepest green (a mixture of Hooker's Green and Warm Sepia) to accent some of the darker shapes. They will seem to recede behind the trunk. Also, add leaves to refine the edges of the tree. Incidentally, after completing the painting, I decided to tone down and neutralize the green color of the tree by overwashing it with Burnt Sienna. This helped to coordinate the green with the other colors in the painting.

Note: Sponging is another effective way to do background trees. Try lighter values on slightly damp paper to get the soft fusing of distant tree shapes.

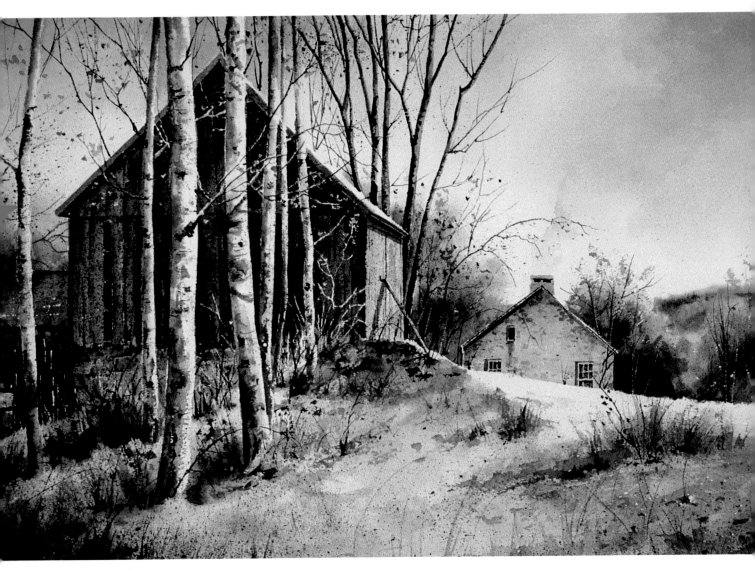

Now I'm going to renege on my statement that we wouldn't paint specific varieties of trees. In this exercise we'll paint that all-time favorite, the birch tree. I make no attempt to paint a botanically correct tree, but my interpretation is convincing and my birches are a popular subject with my collectors. So, dear readers, let's give it a try.

Birches
11½″ × 17½″ (29cm × 44cm)
Watercolor

TECHNIQUES USED:
• Masking
• Drybrush

COLORS USED:
• Payne's Gray
• Raw Sienna
• Warm Sepia
• Yellow Ochre

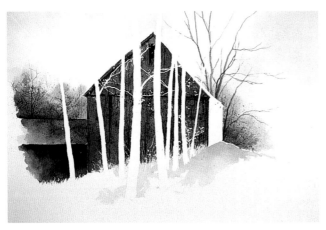

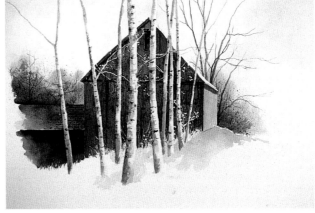

STEP 1

Block in Background Shapes

You'll need a dark background shape in order to silhouette the trees and emphasize their whiteness. It doesn't have to be a barn; any dark shape will do. Roughly sketch a group of trees, paying particular attention to vary the position and size of the trees for interest and depth. Taper the width of the tree as you go up. Slant and curve the trunks so that various interesting shapes are formed in the negative spaces between them. Use masking fluid to mask out the tree trunks, a few of the larger branches and some leaves and twigs before you block in the dark background. If you were doing a complete painting, this would be the time to add any background details (sky, background trees, etc.). After the background is completely dry, remove the masking fluid.

STEP 2

Model Forms of the Trees

Begin to model the roundness or cylindrical shape of the trees. Assume the light source emanates from the right. Dampen each tree in turn and apply a wash of medium gray to the left side, allowing the gray to blend into the white on the right side. Don't try to be perfect. Imperfections accent the unevenness of the bark. Shadow the underside, or left side, of the white branches. Allow to dry. Now, with a deeper value of the same gray, drybrush intermittent areas of the tree using the side of a round brush in a horizontal position. Stroke from left (the shadow side) to right (the light side). After this is dry, use dark values to add some patches and horizontal lines. The patches should resemble diamonds or inverted triangles to indicate the dark scars inherent in birch trees. Also, add a few thin, dark horizontal lines with your liner brush; curve them slightly to indicate the roundness of the tree.

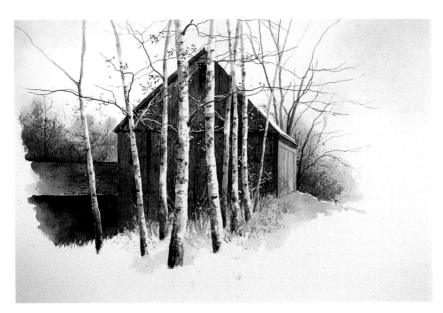

STEP 3

Shadows, Bark, Branches and Leaves

Indicate on the trunks shadows that are cast by branches and other trees. Subdue a few of the trees so that they're almost completely in shadow. This enhances the dimensional quality of the scene and adds variety. Drybrush a few yellow patches on the trunks, particularly at the base of the trees, to represent areas where the bark has peeled. Apply some dark values in this area, too. Add a few dark branches and then paint the leaves. Place light-colored leaves in the dark areas and darker leaves in the light areas.

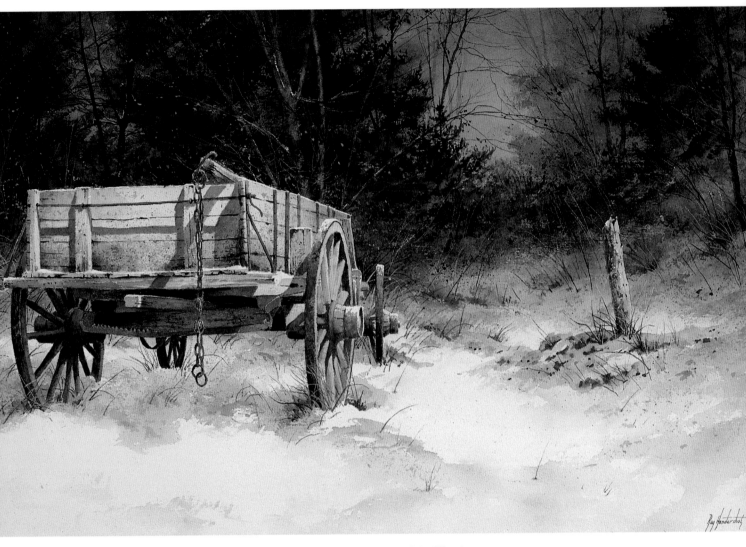

Edge of the Wood
18½″×29½″ (47cm×75cm)
Watercolor

Here's a different approach to painting a background woods. Strong contrasts dominate this painting. The idea is to create a dark background in order to accent the foreground objects and make them stand out in relief. We'll cool the colors, silhouette a few coniferous trees and graduate the values from light to dark (light is far—near is dark) in a series of layers of application, working from the far distance forward. Let's explore the mysteries of a deep winter wooded area in *Edge of the Wood*.

TECHNIQUES USED:

- Masking
- Spattering
- Scrubbing and blotting
- Gouache opaques
- Watercolor pencil

COLORS USED:

- Cerulean Blue
- Payne's Gray
- Ultramarine Blue
- Warm Sepia
- Burnt Umber
- Burnt Sienna
- Acryla Raw Sienna gouache
- Acryla Titanium White gouache
- Raw Umber watercolor pencil

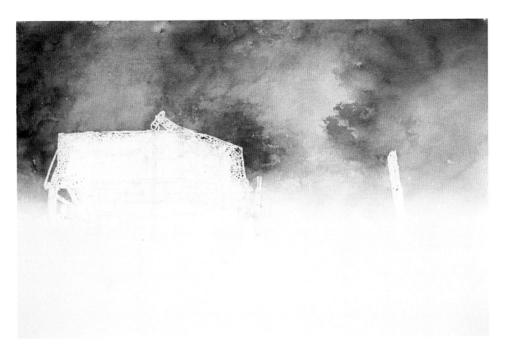

Begin Foreground, Background and Middle Ground

Do a detailed pencil sketch of the foreground items—the wagon and the fencepost. Then mask these areas with liquid frisket in preparation for the background work. When the masking fluid is dry, wet the upper half of your paper and sponge it to a damp, sheenless state. Apply a loose wash of a middle-value, blue-gray tone (a mixture of Cerulean Blue and Payne's Gray), covering the entire wooded area plus the shadowed area in front of the trees. Allow the bottom of this wash to seep into the white foreground for a soft transition. This is the lightest value in your background, and it can be sketchy because most of it will be covered by subsequent applications. While the paper is still damp, apply darker values of Warm Sepia to indicate the location of the dark conifers. As the paper dries and your strokes are able to hold a sharper edge, paint the outline of a middle-distance conifer using the blue-gray mix with a bit of Ultramarine Blue added. Let dry.

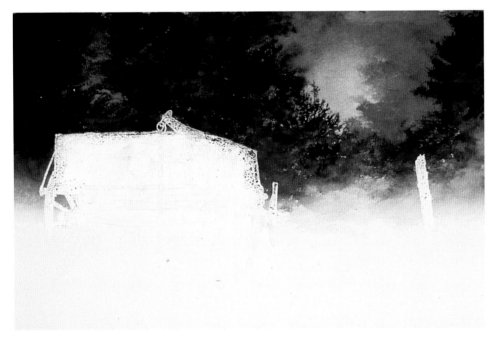

STEP 2

Begin to Define the Conifers

Using your fan brush and Warm Sepia, begin to define the dark brown conifers. Be careful to leave openings for "sky holes." As you approach the bottom, fade into Burnt Sienna to suggest undergrowth. As your initial strokes dry, continue to add darker values to create dimension in the trees. Deepen the shadowed area at the base of the trees.

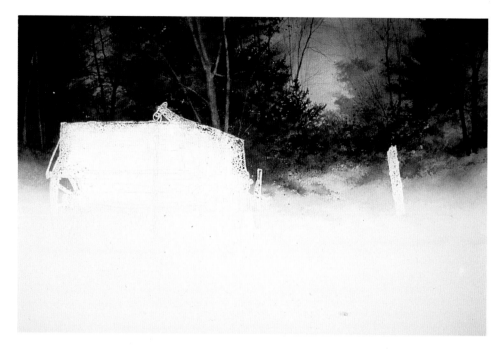

Tree Trunks, Branches and Weedy Areas

Now, using your deepest value (add Ultramarine Blue to your Warm Sepia), paint the dark tree trunks and branches. In the lightest area, add a few blue-gray trunks to suggest distant trees. When everything is dry, lift off the lightest tree trunks and branches with a scrub-and-blot technique. Define some weedy areas in the shadows at the base of the woods. Spatter some blue into this area, also.

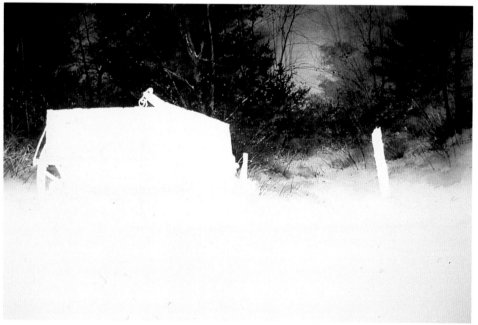

STEP 4

Add Details

I used a Raw Umber watercolor pencil to draw the weed masses at the base of the trees as well as some fine branches in the background. Highlight the weeds with a gouache mix of Raw Sienna and Titanium White to suggest a few leftover leaves.

Finish by adding a few shadows to the light tree trunks and indicating some fine twigs in the foreground. Now remove the masking material and complete the work by painting the foreground objects.

| **Foreground Vegetation**

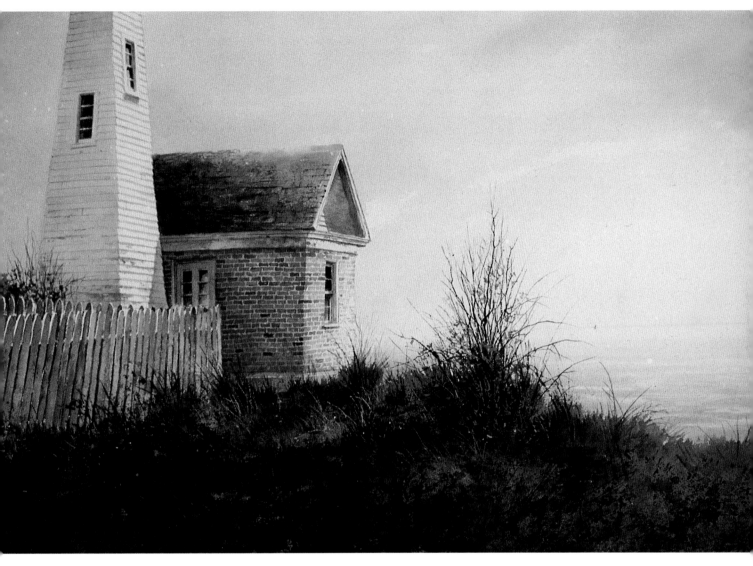

This scene was painted at Pemaquid Point, on the coast of Maine. The wild, wind-blown grasses were a challenge; I think I used every texturing technique in my repertoire to pull this one off. Don't even try to copy my brushstrokes. Just use the referred techniques and allow your imagination to take over. The real secret to painting grasses is being careful to alternate dark and light values, putting dark strokes next to light and light next to dark.

Bell House
18″ × 28½″ (46cm × 72cm)
Watercolor

TECHNIQUES USED:

- Fan brush
- Splattering
- Patting
- Gouache opaques

COLORS USED:

- Hooker's Green
- Raw Umber
- Acryla Yellow Ochre opaque gouache
- Acryla Sepia opaque gouache
- Acryla Titanium White opaque gouache

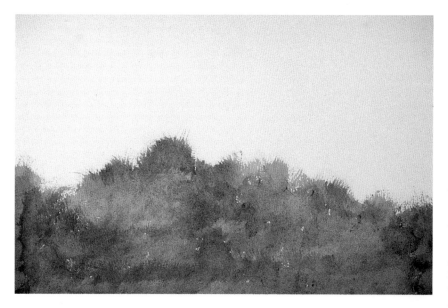

STEP 1
Complete the Initial Wash
No preliminary drawing is needed for this exercise. Simply pick up a fairly fluid mixture of Hooker's Green and Raw Umber in your modified fan brush and, stroking the tip of the brush upward, lay in the upper line of grasses. Vary the direction of your strokes, leaning some grasses to the left and some to the right. Lift at the end of each stroke so the blades of grass tail off at the top. Now complete the remainder of the initial wash, allowing your paint mix to vary in color and value. Don't paint everything green. Leave patches of pure umber to indicate bare ground showing through the grasses. There's no need to be careful at this stage. Any imperfections or skips will be covered in subsequent applications. Allow to dry thoroughly.

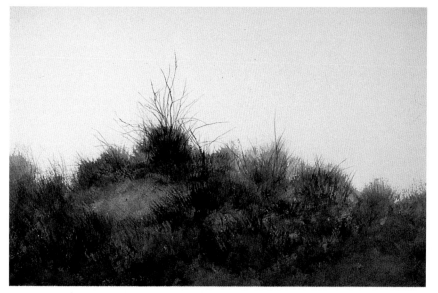

STEP 2
Apply Individual Blades of Grass
With a darker value (use less water) of the same green-brown mixture, apply a second layer of grass-like strokes. Make this layer a little less substantive so that it doesn't completely cover the first application. Again vary the values to create light areas and dark shadowed areas. Use a drier mix to make the blades of grass more individualized and distinct. Now, using a liner brush in an upswept motion, paint individual blades of grass in various directions. Use the green-brown mix for some blades and Warm Sepia for others.

STEP 3
Paint Bush, Sticks and Leaves
Use the Acryla Sepia gouache to paint the branches of the bush and a few scattered sticks and leaves. After this application is dry, do a bit of splatter work on the lower right, and add some dark Sepia textures using the fan brush in a patting motion. Again, let dry.

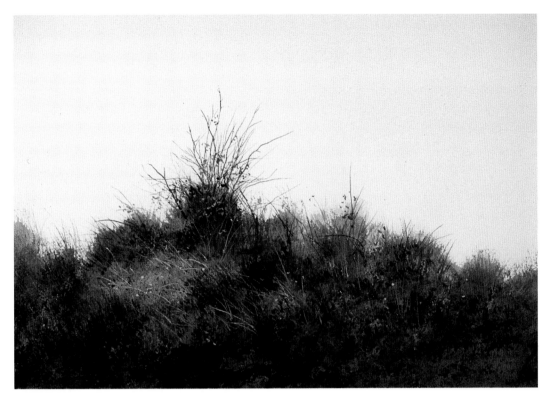

STEP 4

Apply Shadows and Sunlit Areas

Continue building the shadows by fanbrushing a broken, dry-brush application of a Sepia-green mix across the immediate foreground and in other selected spots. Pat on a dark value to indicate foliage in shadowed areas. To finish, paint some lighter grass and leaf shapes, particularly in the darker shadowed areas, with a mix of Yellow Ochre gouache and Hooker's Green. Also, indicate a few lighter weeds in the sunlit areas using your fine liner brush and a mix of Yellow Ochre and White gouache.

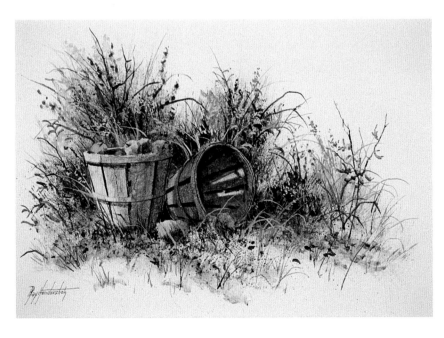

A Warmup for Foreground Vegetation

I often do these simplified vignette studies to practice painting foreground foliage and to perfect the various required techniques. A few of my collectors have seen the vignettes and they have become an immediate success as paintings in their own right. You may want to try them. They don't take a lot of time, they're a lot of fun and they're great for practicing foreground techniques.

Weed Study
11″×14″ (28cm×36cm)
Watercolor

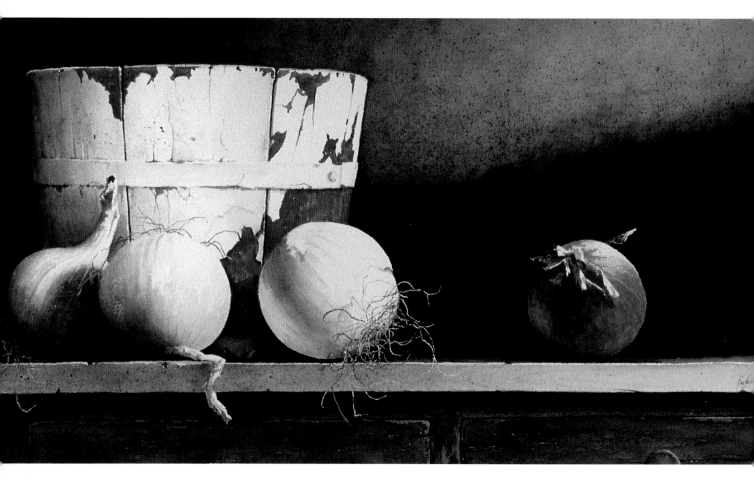

Peels
15½″ × 28½″ (39cm × 72cm)
Watercolor
American Watercolor Society
Exhibition 1997

I'm attracted to antique wooden pieces that bear the scars of age and hard use; they overflow with charm and character. I photographed this old relic at an antique shop in a nearby town. I've been kicking myself ever since I didn't spring for the few bucks needed to buy it. I don't know how many layers of white paint it received over the years, but the thick layers were peeling off in large, thick flakes, revealing an interesting red stain underneath. It made a perfect companion for the white and red onions in the painting *Peels*. Let's paint!

TECHNIQUES USED:
- Spattering
- Scratching

COLORS USED:
- Yellow Ochre
- Raw Sienna
- Burnt Umber
- Burnt Sienna
- Winsor Blue
- Alizarin Crimson
- Payne's Gray
- Warm Sepia

Initial Drawing and Bucket

Complete the basic drawing and apply a wash of very pale yellow over the entire bucket. While this wash is damp, shade the left side of the bucket with a deep value of gray-brown to indicate the light source coming from the right. Allow the shading to blend off on the right side, and be careful to leave a narrow strip on the far left to indicate reflected light. Also, paint around the large flaking paint chip on the lower left, leaving it a bit lighter than the surrounding shading. Leave a narrow band of light along the very top edge of the bucket.

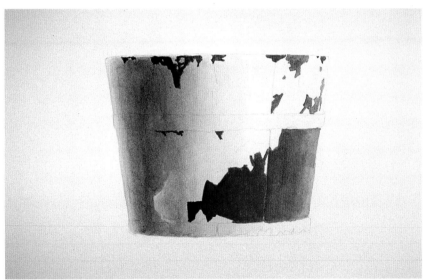

STEP 2

Paint Red Base Wood Areas

My color choice for this red was a mix of Alizarin Crimson and Burnt Sienna shaded with Warm Sepia. Keep the lightest value on those areas furthest to the right and darker moving toward the left. The left side of the crack between the staves should be lighter in value to indicate the direction of light.

STEP 3

Cracks, Splits, Metal Bands, White Areas

Use your liner brush to indicate the dark cracks between the staves and the splits in the wood. Highlight the two metal bands by shading a bit above and below them in a slightly deeper color to make them appear to project out. Add the dark areas where the paint has chipped off to further delineate the bands. Use another, slightly darker wash on the white areas of the bucket to highlight the divisions between the staves. Be careful to avoid the areas just to the left of the cracks.

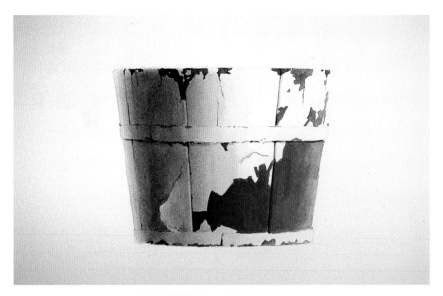

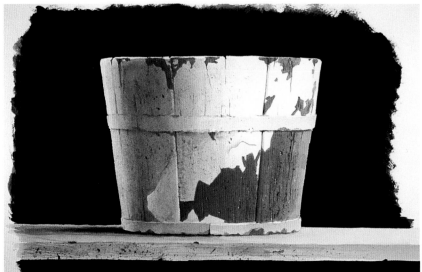

STEP 4

Enhance Illusions of Dimension and Light

Apply a dark spatter to give the illusion of roughness. Add more cracking, particularly in the red area. After this is dry, highlight by scratching with a razor blade just to the left of a few of the cracks. Notice how this further enhances the illusion of form and dimension. The same scratching technique can be used on the left side of a few of the spatter dots to add a dimensional quality and to suggest holes. Finish by adding a few rust spots, and use a wash of blue on the far left edge of the bucket to intensify the illusion of reflected light.

Note: I painted the shelf and black background at this point to show the effect of the light edges on the bucket. I did not use the reflected light on the left side of the bucket on the original painting, but I have often wished I had.

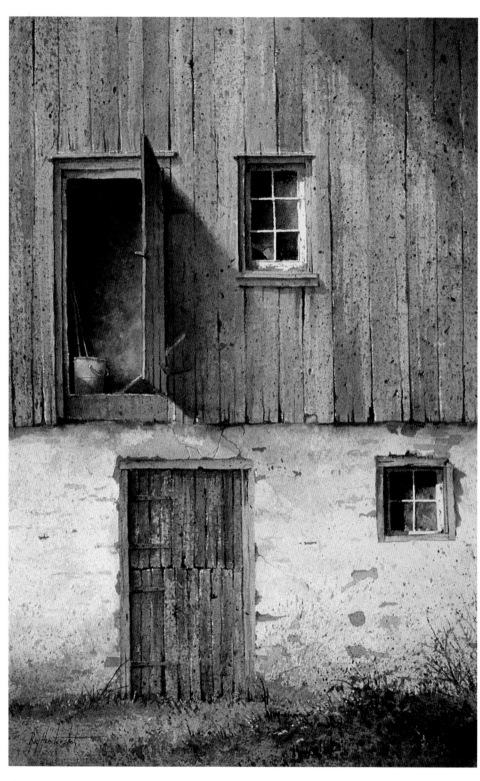

I have a soft spot for these geometric compositions. I guess it's my engineering side showing through. This old barn presented an unusual combination of unequal sizes of square and rectangular shapes—orderly forms arranged in a disorderly fashion. At first glance, this facade seems to be flat and lacking in depth, but the composition takes on a three-dimensional look when you add shadows by the open door and the window casings. In any case, it's a good exercise for painting weathered barnwood.

TECHNIQUES USED:

- Masking
- Spattering
- Splattering
- Drybrush
- Scratching

COLORS USED:

- Payne's Gray
- Warm Sepia
- Burnt Umber
- Burnt Sienna
- Raw Sienna
- Winsor Blue

Open and Closed
19″ × 13″ (48cm × 33cm)
Watercolor

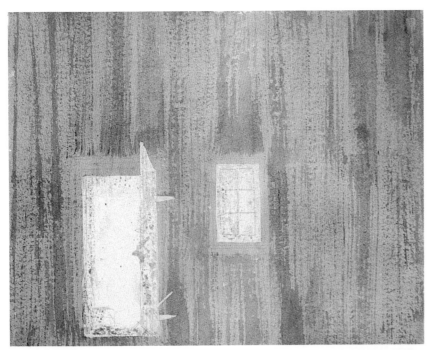

Draw, Mask, Wash and Drybrush

Draw the barn and mask off the areas that won't be painted as barnwood, such as the doorway and window. This allows complete freedom in your subsequent brushwork. Now, lay in a wash of mixed grays, browns and blues over the entire area. Try to avoid a uniform color by varying the warm and cool tones. I usually keep warm colors on the side favoring the direction of the most light and cool colors on the opposite side. After this is completely dry, use your fan brush in a dragging manner to drybrush darker values of the same colors over the entire area, avoiding the masked window and doorway. This represents the roughness as well as the many marks often found on aged wood.

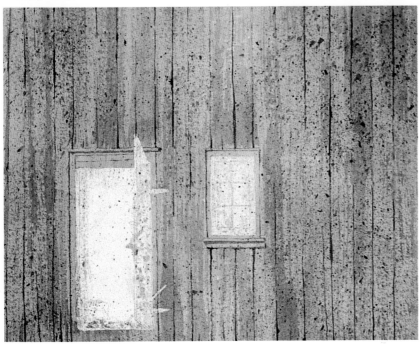

STEP 2

Spatters, Splatters, Cracks and Knotholes

Follow with some spatters and splatters in a very dark value. Delineate the cracks between the boards with dark, fairly parallel, vertical lines in a lost-and-found fashion. The positioning of these may be suggested by the dry-brush marks. Be creative by indicating split or broken boards, particularly at the bottom, where they usually show the most harsh signs of deterioration. With this same value, add a few larger spots to suggest knotholes.

Shadows, Light, Doorway and Window

To give the illusion of projecting and receding planes, shadow a few of the boards with a slightly darker value of the initial wash. Also add some shadows in the upper corners, which directs attention to the center of the painting. Then, with the corner of a razor blade, scratch white lines just to the right of a few dark cracks to indicate light reflecting off the edges of the boards. After this has dried, remove the original masking and paint the doorway and window. It helps to re-mask the window frame and mullions before painting in the darks of the window panes, but you can always paint the panes freehand. Finish by adding shadows to the right of the door and to the inner top and left areas of the window and door frame (keep in mind the source of light is coming from the upper left). Place the darkest values closest to the object casting the shadow, and gradually lighten the values as you move away from the object.

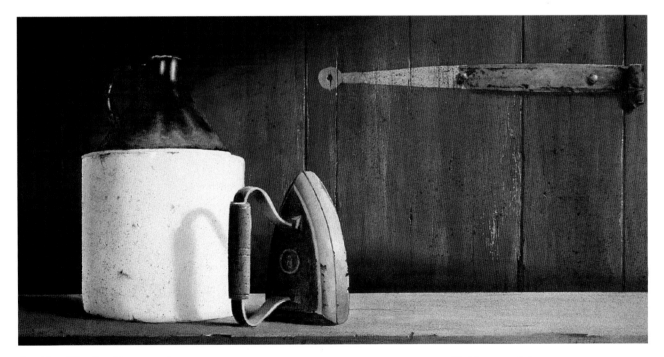

Another Use for Barnwood

Barnwood textures are not limited to barns. In this still-life painting, the techniques you just learned were used to create the roughness of the old wooden backdrop. Use your imagination to think of other ways to use these texturing methods.

Flat Iron and Jug
12″ × 24″ (30cm × 61cm)
Watercolor

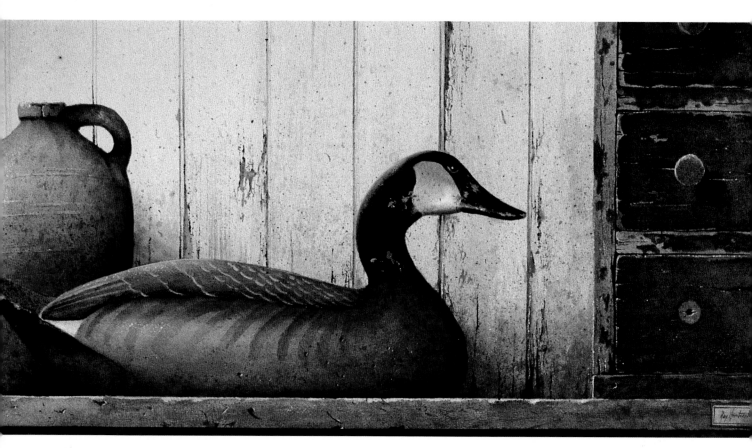

This old spice chest has seen better days. In some spots, only remnants of the blue paint remain. Peeling paint, worn drawer edges and a missing knob made this old heirloom an interesting subject for *Canada and Jug*. It's a wonderful piece for this exercise in painting worn wooden furniture. Now, let's go to work.

Canada and Jug
14½″×29″ (37cm×74cm)
Watercolor
American Watercolor Society
Exhibition, 1993

TECHNIQUES USED:
- Masking
- Drybrush
- Spattering
- Scratching

COLORS USED:
- Yellow Ochre
- Raw Sienna
- Raw Umber
- Warm Sepia
- Burnt Sienna
- Cerulean Blue
- Payne's Gray

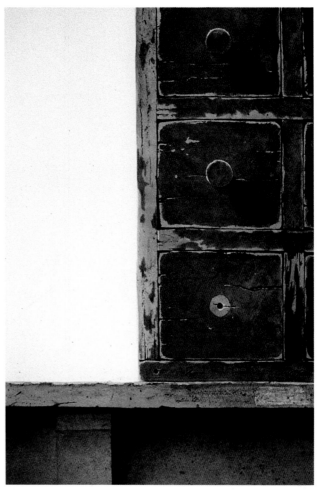

STEP 1

Sketching, Masking and Washing

Make a rough sketch of the subject. Use liquid frisket to mask off the only white area you need to preserve—the label on the shelf. Tone the entire paper with a pale yellow to "age" the wainscoting and to give the subsequent highlights a glowing warmth. When this is dry, mask off the areas you want to be highlighted, such as the top edge of the shelf, the upper left side of the knobs, the lower right side of the holes and the left edge of the chest. Now wash in the base color of the chest with a darker yellow-brown to simulate bare wood.

Use a dark color to paint the cracks in the wood, the two holes and the lines suggesting the perimeters of the drawers. You may want to mask the bare wood areas in preparation for painting the blue on the chest. Masking results in a harder edge, so I chose to paint around them. Use opaque colors for the blue paint; I suggest a mix of Cerulean Blue and Raw Umber. Vary the combination to avoid too much uniformity of color.

STEP 2

Place Darkest Values and Shadows

Drybrush some darks on the chest edge and the shelf, and use the same paint to spatter a few areas. Then paint the shadows under the shelf and to the lower right of the knobs. Remember to place the darkest value closest to the object casting the shadow and to gradually lighten the values as you move away from the object.

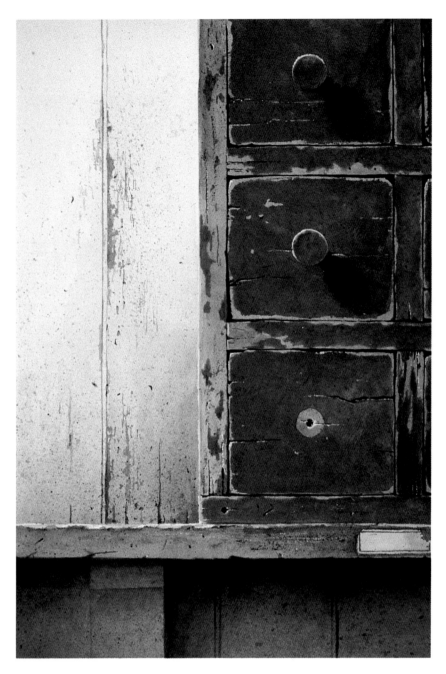

Darks, Details and Highlights

Finish the exercise by painting a darker area where the wainscoting meets the shelf and the base of the chest. This will define the light edges. Apply a few spatters, indicate the board separations in the wainscoting, and paint a few areas suggesting peeling paint. Finally, remove the frisket and notice the dimension those little highlights add to the finished piece. At this point, you may want to add more highlights. Using the corner of a single-edge razor blade, make a few scratches just to the right of the cracks and on the right side of the holes to indicate that light is hitting these areas from the upper left.

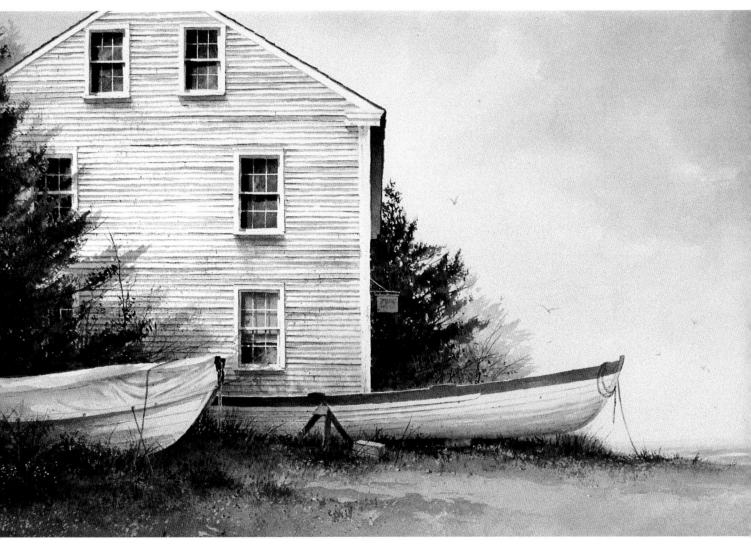

The New England coastal scene is dotted with these wonderful white, clapboard-sided buildings. I find it interesting the way the shadows play off the irregular siding, particularly when the source of light comes from a high, acute angle, as in the case of *Whaleboats*. It's a habit of mine to begin this type of painting with a wash of light yellow to give warmth to the sunlit areas. In this case, however, I didn't apply the wash because I wanted the strongest possible white to contrast with the darkened surroundings. The Arches paper I used for this exercise already has a natural creamy color to it. Let's begin.

Whaleboats
17½″ × 29½″ (44cm × 75cm)
Watercolor

TECHNIQUES USED:
- Masking
- Paint and Blot
- Spattering

COLORS USED:
- Raw Umber
- Warm Sepia
- Payne's Gray
- Raw Sienna

 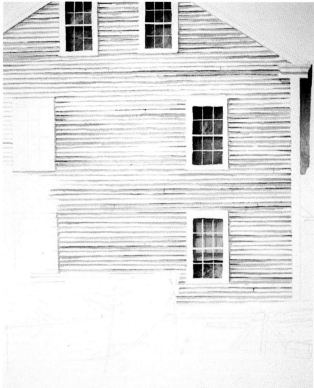

STEP 1

Detailed Drawing and Shadow Areas

Make a detailed drawing. The lines should be fairly parallel and equidistant, but don't be tempted to use a straightedge; a little variety will add to the rustic quality of the finished product. Mix a generous batch of warm gray. This color is used for all the shadowed areas on the building. Begin to delineate the clapboards by painting the shadows beneath each board division. Make the top edge fairly straight, and undulate the bottom edge. Vary the width of the shadows—even covering some of the board widths completely—to suggest some projecting and receding boards. Add shadows to the right of and underneath the window frames. The shadows to the right of the windows have a characteristic triangular shape caused by the inward slant of the clapboards.

STEP 2

Deepen Shadows, Mask and Paint Windows

Give further depth to the shadows by strengthening the dark lines between the clapboards in a few places, particularly in the wider shadowed areas and to the right of the windows, where the shadows are darker. Now mask the mullions in the windows with fine lines of liquid frisket using your drawing pen or liner brush. Also mask around the perimeter of each window. After the frisket is dry, paint the shaded window with Raw Sienna and the shadows of the window frame and mullions with Raw Umber. Now paint the remainder of the windows in a dark value using a paint-and-blot method. This method gives the illusion of reflections in the glass. After drying, remove the frisket.

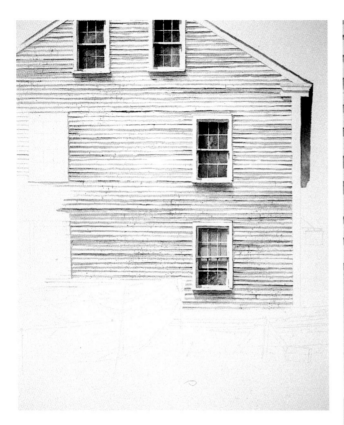

STEP 3

Finish Windows, Roof Line and Details

To complete the windows, paint the shadowed areas inside the window frames using the same color mix you used for the clapboard shadows. Allowing for the source of light from the upper left, apply shadows to the inside left and inside top of the frames. Use the same color to paint the shadows under the windows. Then add darker shadows to the glass areas on the left, top and bottom of the middle division of each window. Notice how this simple step increases the illusion of dimension and depth. Finally, add the roof line and, in the Hendershot tradition, add a few spatters in selected spots to indicate areas of deteriorating paint.

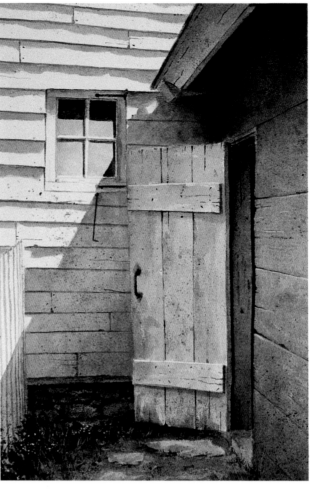

Another Example

This composition more closely illustrates the complex patterns of light and shadow that are cast by old, uneven clapboards, turning a very ordinary scene into one of intricate design elements.

Cloister Back Door
17½″ × 12″ (44cm × 30cm)
Watercolor

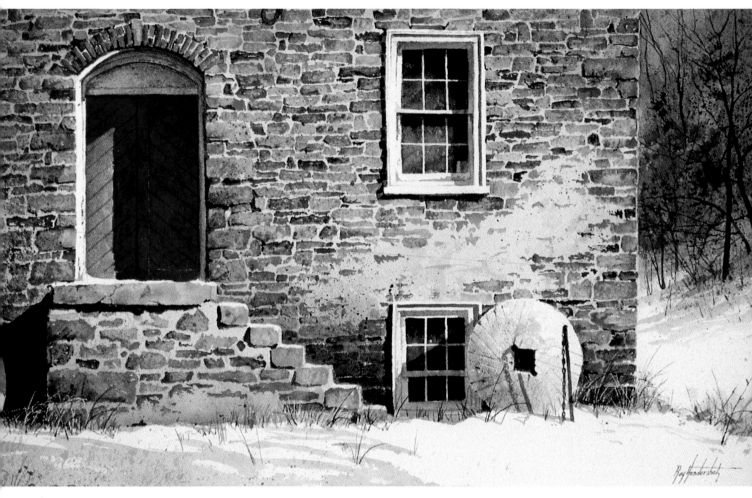

Here's another geometric composition. This time, an old mill front is the subject for an exercise in painting a fieldstone building. The temptation with a subject like this is to meticulously paint every stone and to separate each one with precise, distinct mortar lines. Normally I resist this temptation, opting for a lost and found approach, in which lines and shapes dissolve, fade or blend into others and then reappear, with some areas left free of stonework and some mortar lines obliterated by cracks and crevices. It's far more interesting to viewers if you leave something to their imaginations. It also puts the emphasis where it belongs—on the overall composition, not on the configuration of the stonework. Thanks to this exercise, I've painted more than my share of stones. Care to try a few?

Red Door
12″×21½″ (30cm×55cm)
Watercolor

TECHNIQUES USED:
- Masking
- Paint and Blot
- Spattering

COLORS USED:
- Raw Sienna
- Raw Umber
- Burnt Umber
- Payne's Gray

Drawing, Masking and First Wash

Make a light pencil drawing to place the elements of the composition. Mask the doorway, the windows and the mill-stones with liquid frisket. Also, mask a thin line on the tops of the steps to suggest snow and use a liner brush to mask a few weeds at the base of the building. When the frisket is dry, apply a gray-brown wash to the entire building, keeping the left side more gray and the right side more brown.

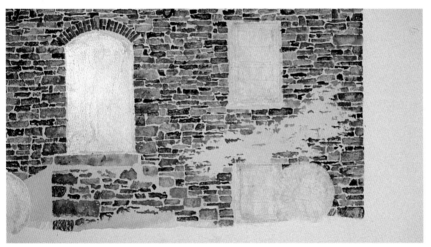

STEP 2

Define the Stones

Use a paint-and-blot procedure, which produces an irregular, mottled, stonelike texture. Be careful to vary the color, value, size and shape of the stones, and fade them away in a few areas to avoid predictability. Complete this step by painting shadows on the left and bottom edges of some of the stones, suggesting the light source is from the upper right.

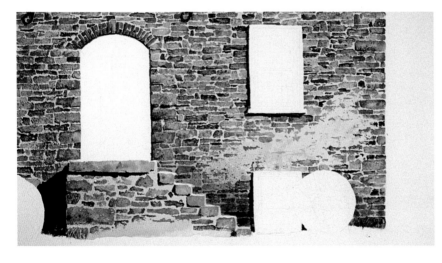

STEP 3

Shadows, Stairs and Final Details

Paint the shadows cast by the windows, steps and millstones. Indicate a few stone forms within these shadows and add some dark spatters. This makes the shadows more transparent. Define the stairs a bit more and allow them to project from the rest of the building by shading the stone area to the immediate right a value darker. Indicate some missing mortar in spots by darkening the lines between the stones. Now remove the frisket and complete your painting.

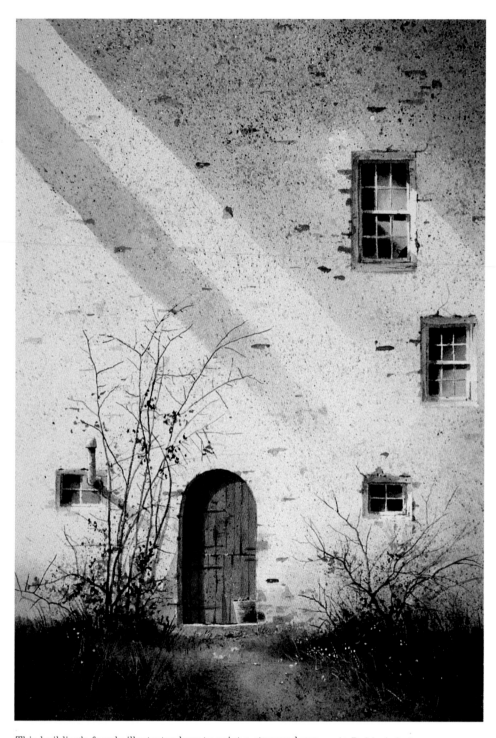

TECHNIQUES USED:
- Spattering
- Splattering
- Masking
- Reverse Spattering

COLORS USED:
- Raw Sienna
- Raw Umber
- Payne's Gray
- Warm Sepia
- Burnt Sienna

This building's facade illustrates how to paint a stuccoed surface. Many of the old farm buildings in my area were originally built of stone. Over the years, they have been surfaced with stucco, probably to improve insulation. The process of painting this granulated surface isn't difficult, but it is messy, so get out your spattering brushes, towels and masking fluid and paint along with me.

At Baldwin's
19″ × 13″ (48cm × 33cm)
Watercolor

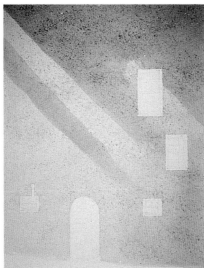

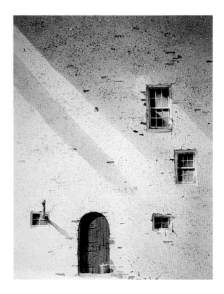

STEP 1
Drawing, Washes and Frisket

Make your initial rough drawing. Apply a diluted wash of Raw Sienna and/or Raw Umber to the building area to establish a sunny base color. When it has dried, apply liquid frisket to the door and windows, including the frames. This allows complete freedom for the subsequent texturing process. Now apply a light spatter of liquid frisket to the entire building area and allow to dry. Apply another wash of Raw Sienna and Raw Umber. Later, when the spattered frisket is removed, the sprinkling of light-valued dots will look like highlights in the roughened surface.

STEP 2
Shadows and Spatters

Now is the time to establish shadow patterns. I painted some shadows from an off-picture source in the upper portion and on the left side of the painting to focus more attention on the door and surrounding details. This brings us to the messy part. With a towel shielding the lower part of the painting, spatter Raw Sienna and diluted Raw Umber mostly in the sunlit areas. Spatter undiluted Raw Umber, Payne's Gray and even some Burnt Sienna in the shadowed areas. Vary the size of your dots by mixing in some splatters, as well. Allow to dry completely, and remove the frisket. Now you can see the value of the earlier frisket spatter, particularly in the shadows.

STEP 3
Blemishes, Shadows and Final Details

Every stuccoed surface has its share of blemishes. Use a liner brush to indicate the stones and cracks. Add Raw Sienna to the shadows and Raw Umber to the sunlit areas. Mask off the window mullions and paint the windows with a varying mix of Warm Sepia and Payne's Gray; use more Sepia in the shadows and more gray in the sunlit areas. Now paint the door with a mix of Burnt Sienna and Payne's Gray. When all this is dry, continue to refine the shadows in the windows and door, and then add the final details. Often, when the final elements are added, the result looks a little weak and lacks contrast. To punch it up I deepened the shadow in the upper right of the painting and roughened the texture of the building with a few more dark spatters.

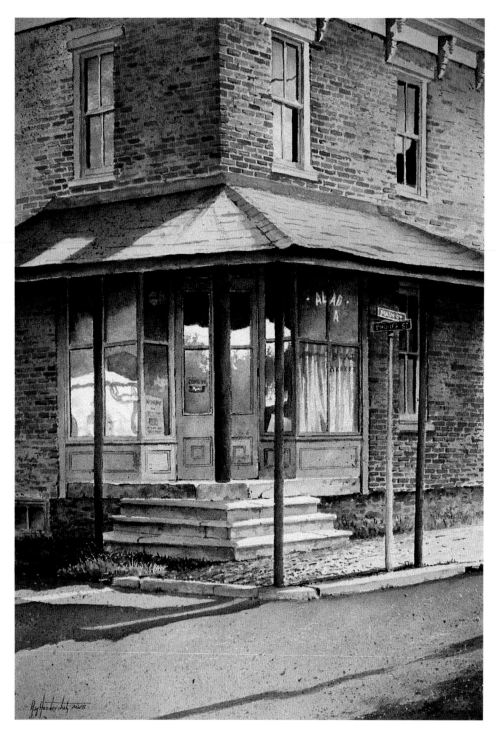

Main and Church
14″×20″ (36cm×51cm)
Watercolor

TECHNIQUES USED:

- Acrylic Medium Additive
- Spattering

COLORS USED:

- Raw Umber
- Burnt Sienna
- Raw Sienna
- Payne's Gray
- Alizarin Crimson

Not that long ago, before the era of giant supermarkets, it seemed every street corner had a small, family-owned grocery store. The one in this painting was still in operation the year we moved to our present hometown. Since then it has undergone many changes. It housed a number of businesses and was painted a rainbow of colors. During one severe winter, the original roof caved in and had to be removed. The way I painted it is the way I want to remember it—a flashback to simpler days. Now, try your hand at painting the brickwork texture of the corner store at *Main and Church.*

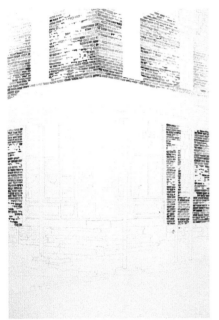

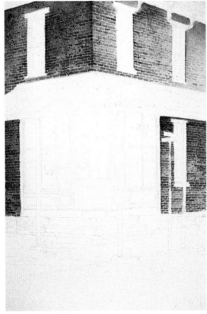

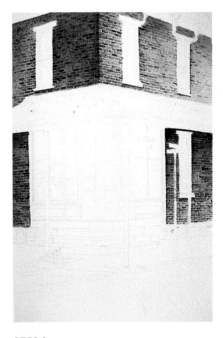

STEP 1

Detailed Pencil Sketch and Bricks

I recommend that you use layout lines to keep the brick rows straight and in proper perspective. Paint the brick designs using a varying mix of Alizarin Crimson and Burnt Sienna. Add a small amount of acrylic medium to your paint mix at this point to make it more resistant to lifting during the subsequent washes. In my painting, I offset each course in what masons refer to as a "running bond pattern," but you needn't be that exact. Much of this preliminary work may be covered in the following steps. In fact, it's a good idea to leave some open areas to avoid a monotonous pattern. Fade out the brick pattern in the upper corners. This focuses more attention toward the center of interest, or the entrance of the store.

STEP 2

Mortar, Shadows, Sunlit Areas and Spatter

Now paint the mortar lines and add dimension by defining the shadowed areas. Overwash the right side of the building (the sunlit side) with a pale mix of Burnt Sienna and Raw Umber. Now do the left side (the shadowy side) with a wash of Burnt Sienna and Payne's Gray. Use this gray mixture in other obvious shadowed areas, such as beneath the overhang of the roof and at the top of the painting, beneath the cornice. After it has dried, spatter a few areas to add a rustic touch to the brickwork.

STEP 3

Accent Bricks With Shadows

Accent a few of the bricks with deeper values of the previous colors, particularly in the shadowed areas. This gives variety to the brick pattern. Now, using the deepest value of these colors, add shadow lines to the left side and bottom of some of the bricks on the right side of the building and to the bottom of some of the bricks on the left side of the building. Only a few bricks need to be shadowed to give dimension to your brickwork. Let the viewer fill in the blanks.

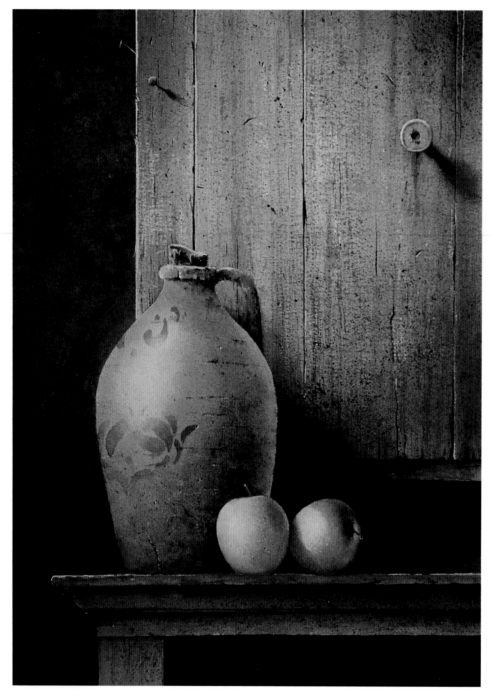

An antique jug becomes an interesting subject for this exercise in which we'll paint a smooth, reflective surface. The lightest areas, such as the highlights on the jug, apples and knob, are unpainted areas of the white paper. However, to avoid creating a hard edge, no masking was done to preserve these white areas. I think a soft transition from the highlight to the surrounding areas best emphasizes the roundness of the objects.

Apple Cider is another painting in my geometric composition series. This time the subject is a still life, but I used essentially the same techniques that I used in painting the building facades. Painting the worn wooden cabinet, for example, requires the same techniques as those we used in painting the side of the barn for *Barnwood*. The subject of this exercise, however, is the antique ceramic jug. Incidentally, I am putting the cart before the horse on this one. Normally I would paint the background first but, for the sake of this exercise, let's begin with the jug.

Apple Cider
21″ × 15½″ (53cm × 39cm)
Watercolor

TECHNIQUES USED:

• Spattering
• Scratching

COLORS USED:

• Cerulean Blue
• Payne's Gray
• Raw Umber
• Burnt Umber
• Raw Sienna
• Burnt Sienna

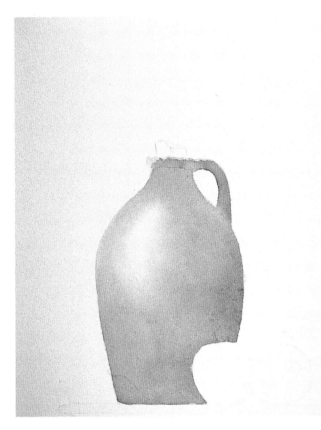

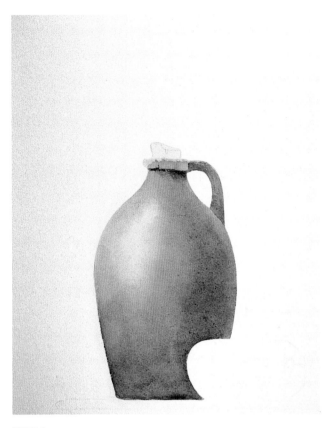

STEP 1

Drawing, Apple Masking and Jug

Make your drawing and mask off the apple shape on the lower right. Then wet the entire jug area and apply a wash of blue-gray. Use darker values on the right and progressively lighter values as you move to the left. Lessen the intensity as you approach the highlight, letting the color fade into the white of the paper. While this wash is wet, float in a few warm colors to show the reflection of external objects and to add more variety to the color of the jug.

STEP 2

Further Develop the Jug Form

Paint deeper shadows on the right using a mix of Burnt Umber and Payne's Gray. Allow the value to fade into the lights on the left side. Rewet the highlight during these subsequent washes to avoid creating hard edges. Apply deeper tones on the handle and underneath the lip of the jug.

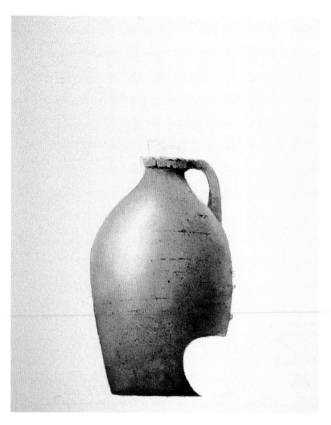

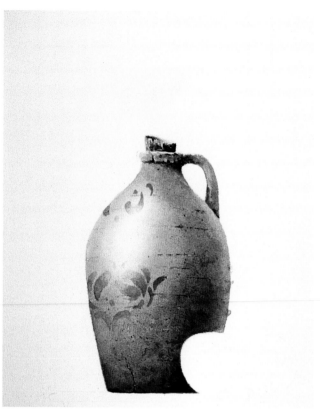

STEP 3

Age the Jug's Surface

The jug's surface is too smooth at this point; age it a bit. Apply spatters of blue, gray and dark brown, keeping the lighter-colored spots near the light side of the jug and the darker spots near the darker side. The spatters give an illusion of bumpiness to the surface of the jug. Later, we'll develop some of these spots into holes. Suggest some "turning lines" from the potter's wheel and add a crack or two to further develop the rustic look.

STEP 4

Add Final Details to Jug

Add those final details that give the jug its character. With your razor blade, scratch highlights on the right and lower side of some of the larger dark spatters, transforming them into holes. Also, scratch just underneath the turning lines. Now add the blue designs, being careful to let them fade into the highlight. At this point, I thought the base of the jug needed to be darker to focus more attention onto the highlight. Finish by painting the cork.

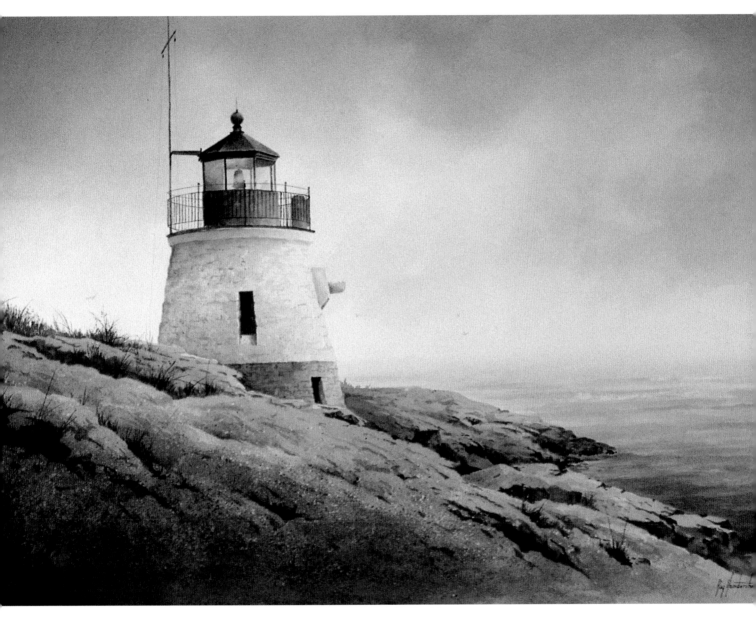

I probably should have named this painting *A Study in Gray*. Talk about your limited palettes! This painting was done using only three colors, but they effectively captured the cold, damp New England morning with its shadowed foreground silhouetted against a misty sea and sky. Notice that there is no delineation between the sky and the horizon, which further emphasizes the heavy mist. This stubby little lighthouse, located near Newport, Rhode Island, is the subject for this exercise in painting a rocky coastline.

Castle Hill Light
20½″ × 29½″ (52cm × 75cm)
Watercolor

TECHNIQUES USED:
- Acrylic Medium
- Reverse Splattering
- Spattering
- Fan Brush Grasses

COLORS USED:
- Payne's Gray
- Raw Umber
- Warm Sepia

Pencil Drawing and Rock Shapes

Make a light pencil drawing of the basic shape of the shoreline, and apply a medium-value gray-brown wash to the entire rock area. Use aerial perspective by varying your wash, cooler (more gray) at the top and warmer (more brown) at the bottom. Then, with a slightly deeper value of the same colors, add a few irregular rock forms. No need to be too precise at this point; we're only trying to identify basic shapes and positions.

STEP 2

Rock Forms and Grassy Areas

Now use the darkest values to suggest cracks and crevices in and between the rocks. It's important, at this point, to establish a more definite pattern of rock forms. Try adding a little acrylic matte medium to your watercolors. It will render this application impervious to moisture and help protect the details from subsequent washes. Add some grassy areas using the tip of your fan brush in an upswept motion.

STEP 3

Add a Few More Details

Continue to form the rock masses with deeper shadows. I disliked the wormlike shape of one of the rocks in the left foreground, so I altered it with additional dark crevices. Now, using your bristle brush and masking fluid, reverse splatter the rock area, particularly in the immediate-left foreground. Follow with a darker version of the gray-brown wash. When it has dried, rub off the frisket. Now apply a dark spatter to the same area. This suggests a rough stone surface texture. Complete the exercise by adding a few more details to further emphasize the undulating surface of the rocks. You may have noticed a difference between the exercise and the finished painting. After completing the remainder of this painting and viewing it in a trial mat, I decided I needed an even darker immediate foreground to focus attention upward.

Create Moods and Effects

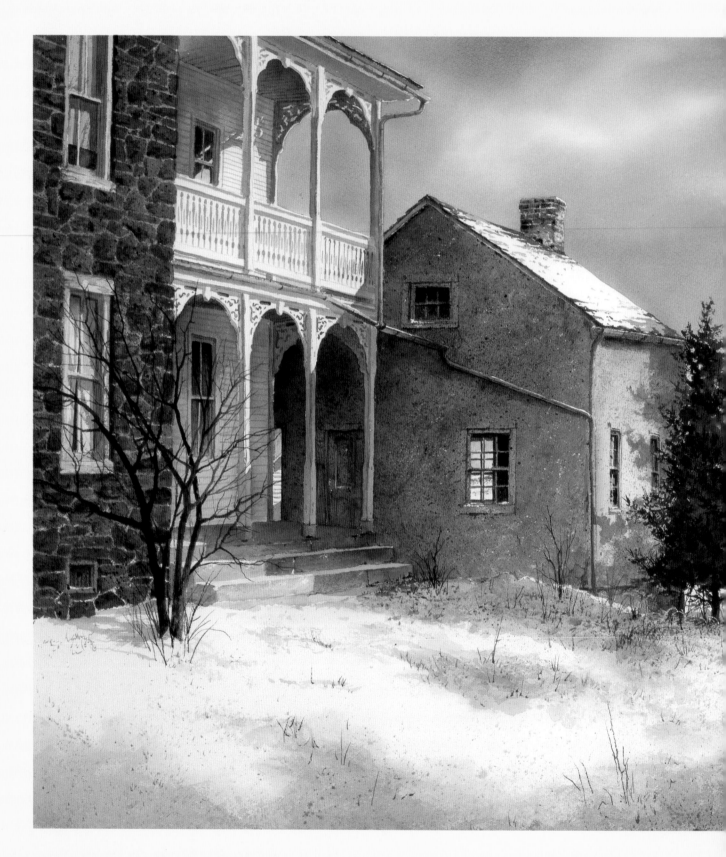

In this chapter we'll look at texturing techniques to create moods and effects intended to elicit a strong emotional response from the viewer. Some of the exercises include additional techniques that may help boost your artwork to the next level.

Summer Kitchen
20″ × 29½″ (51cm × 75cm)
Watercolor

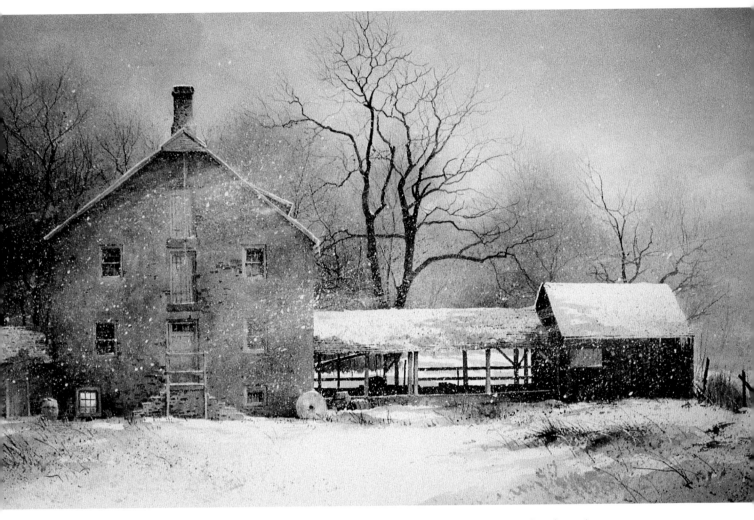

Blizzard at Stover's
18½″ × 29″ (47cm × 74cm)
Watercolor

TECHNIQUES USED:

- Acrylic Medium
- Spattering
- Spritzing
- Fan Brush Work

COLORS USED:

- Raw Umber
- Payne's Gray
- Warm Sepia
- Burnt Umber
- Acryla Titanium
 White gouache

Here in my native Pennsylvania, harsh winter storms are not a welcome sight. From an artist's point of view, however, a blinding, driving snow is fascinating, and I am compelled to paint it. I do at least one of these blizzard pictures every year. The buildings are incidental to this exercise other than to set the stage for the falling snow. Normally I paint from back to front, doing the buildings last. But for the sake of this exercise, I'll concentrate solely on the techniques used to paint the snowstorm.

I protected the buildings with liquid frisket while I completed the background. Painting a convincing snowstorm (or a convincing fog) is a matter of aerial perspective. We'll use a lot of white overpainting and spatter work, so take the precaution of adding acrylic matte medium to your watercolors to make them more water insoluble. This allows you to overpaint without disturbing the preceding applications.

STEP 1

Sky, Trees and Spatter

Wet the entire area above the buildings. Then lay in an uneven wash of Raw Umber and Payne's Gray over the entire sky area. Adding just a bit of Acryla Titanium White gouache to this mix gives it an icy, cold look. While this is still damp, paint the distant tree line using a bristle fan brush and a stronger value of the same colors. This wet-in-wet treatment allows the applications to bleed and blend, giving a soft, atmospheric quality to the background. Now begin to define some trees in the background with your liner brush and a diluted brown-gray mixture favoring the gray. Add a bit of spatter using the same mix.

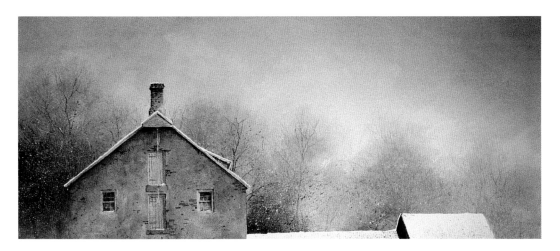

STEP 2

Snowflakes and White Branches

Give the distant tree line a fine, mistlike coating of snowflakes using a stencil brush and Acryla Titanium White to spritz a layer of white over the trees. Don't make this application too wet. If you need more, allow the first coat to dry before spritzing again. Unfortunately, this application covers much of the detail you've worked so hard to achieve, but it does provide the effect of depth and distance. Add a few white branches by loading your fan brush with thick white paint and dragging the bristle tips in various directions across the background trees.

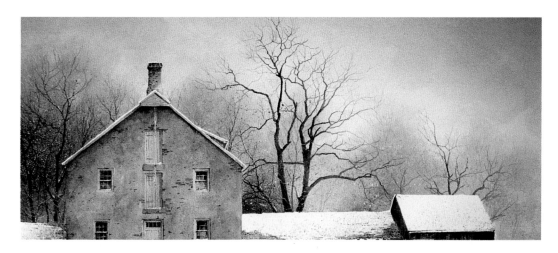

STEP 3

Middle-Ground Trees and Branches

If you painted the buildings first, remove the frisket and add the middle-ground trees. Notice how this second layer of darker and more-defined shapes enhances the illusion of depth. Now add some white to the top of some branches to indicate the accumulation of snow.

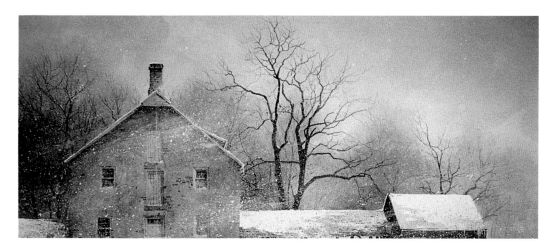

STEP 4

Suggest Strong Wind Movement

The final step is not for the faint of heart. We want to suggest strong wind movement in our blizzard. Using a fan brush and moderately thick white paint, drybrush inter-mittent diagonal strokes across the building, in this case from upper right to lower left. Initiate some of these strokes at the roofline of the building to indicate snow blowing from the roof. Add directional spatters in these areas to suggest wind move-ment. Finish by applying a coarse spatter of white across the entire painting. Try using your fan brush as a spattering tool. The long, flexible bristles will produce larger snowflakes than the smaller background versions.

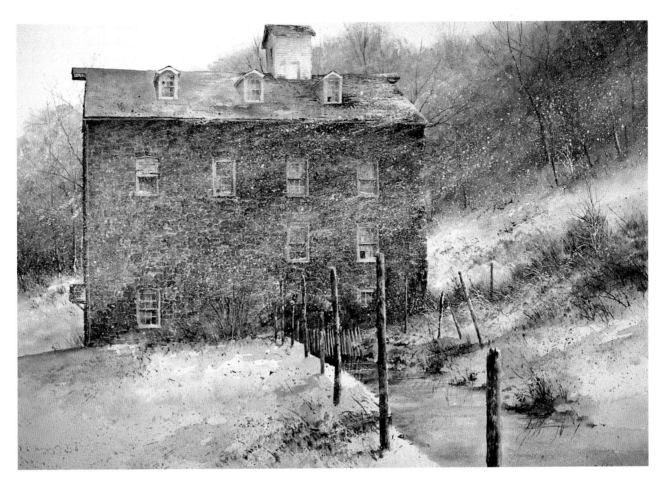

Another Example

This was my first and probably most successful blizzard painting. It was published in one of the Splash series books.

Blizzard
20″ × 29½″ (51cm × 75cm)
Watercolor

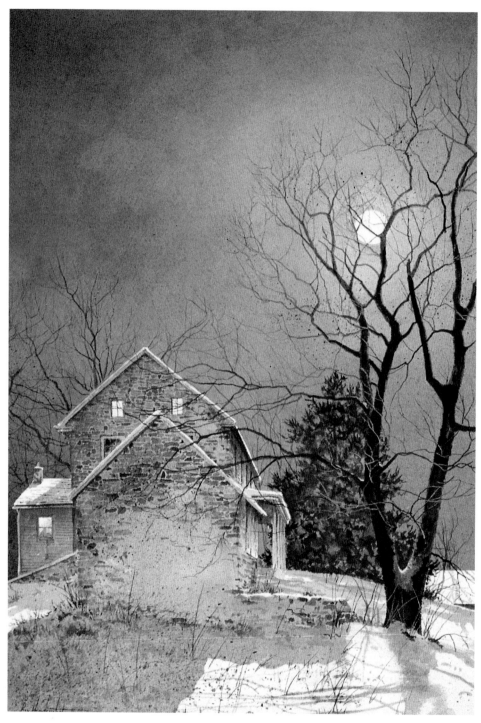

TECHNIQUES USED:

- Masking
- Spatter

COLORS USED:

- Payne's Gray
- Raw Umber
- Raw Sienna
- Acryla Sepia
 gouache

My wife refers to this painting as "the spooky one." I view it as a study in contrasts. Probably the moon is never that white nor the strength of the shadows that severe, but I'm allowed a certain amount of license as an artist, and I chose to exercise it in the painting of *Working Late*. I envision myself sitting at the kitchen table behind that lit window, taking care of some late business before going to bed on this cold winter evening.

Working Late
18″ × 13″ (46cm × 33cm)
Watercolor

STEP 1

Drawing, Masking and Tree Shape

Make a light pencil drawing. Then mask off the building, the entire foreground and the moon. On large areas like this, I often apply liquid frisket only to the perimeters and use masking tape in the interior. If you choose to go this route, be extra careful that you keep fluid washes away from the masking tape, or you may get some seepage beneath it. Now, block in the general shape of the tree with Acryla Sepia gouache to preserve it through subsequent washes.

STEP 2

Apply Gray Sky Wash

Prepare a moderate amount of a neutral gray. Dampen the sky area in about a 3″ circle around the moon. Begin applying the wash with a large, soft brush (I used my 2-inch flat Sable Essence brush). Start at the moon and work outward in ever-increasing circles. The dampened area around the moon will dilute the paint, but the value will get increasingly darker as you move away from the moon. When dry, remove the frisket from the moon.

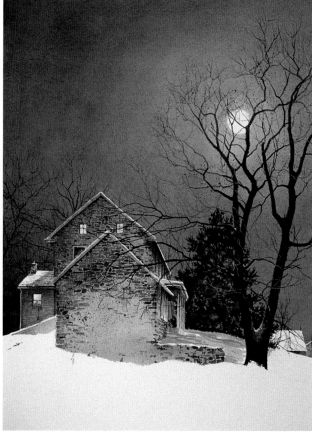

STEP 3

Refine Trees and Sky Wash

Now strengthen the value of the tree and add more branches to give it form, making sure that a number of branches pass in front of the moon to give it a mysterious look. If the sky is perfectly dry (and don't attempt this if it isn't), darken the upper corners of the painting with another wash of the same mix. Carefully blend it, fading out as you move toward the moon. Add a few bare tree forms on the left and a silhouetted coniferous tree in front of the house. Let dry, and remove the masking.

STEP 4

Finish the Other Elements

Before painting the house, be sure to mask off the lit windows because they'll eventually receive a hint of light yellow (techniques for painting windows are covered in other exercises). Then paint the foreground shadows, making sure that their shadow patterns radiate out from the position of the moon. Finish by adding a few weeds and some spatter in the foreground.

exercise | Water Reflections

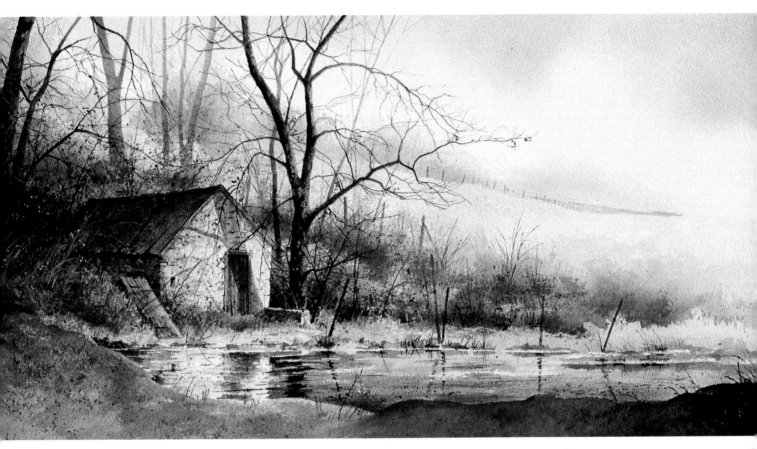

Reflections in water can vary greatly. The images are influenced by the surface condition of the water. Near perfect mirror images are possible only if the water surface is absolutely still and smooth. The images begin to break up as the surface is disturbed by either water movement or surface debris. The greater the disturbance, the more distorted and less visible the reflection. In my opinion, a slightly broken image is the most interesting, and that is the subject of this exercise. To save time, we'll assume that all of the objects to be reflected have already been painted. Let's begin!

Springhouse
15″×29″ (38cm×74cm)
Watercolor

TECHNIQUES USED:

• Drybrush
• Masking
• Spattering
• Scratching

COLORS USED:

• Raw Sienna
• Burnt Sienna
• Payne's Gray
• Burnt Umber
• Burnt Sienna
• Warm Sepia

STEP 1

Make Guidelines and Apply Frisket

Pencil in guidelines in the water area by extending the lines of the major objects being reflected (the edges of the spring-house, the root cellar door and the fenceposts). You can use a straightedge, but the lines don't need to be perfect. Diagonal lines are reflected at an opposing angle. To save some of the white areas for highlights, paint a fine line of liquid frisket along the far shoreline and add a few horizontal streaks in the water. The frisket is nearly impossible to see in this example, so refer to the picture of the finished painting on page 77 to get an idea of how to apply it and where to put it.

STEP 2

Paint Reflections of Objects

Paint the local colors of the springhouse in the water, following the penciled guidelines. Do this in a lost-and-found manner, allowing streaks of white paper to show here and there to indicate water surface disturbance. Extend this feeling of movement by painting the edges of the building with broken, squiggly lines. The more skips and the more erratic the lines, the greater the suggestion of water movement. Paint the reflection of the root cellar door using the same method. Now add some details, keeping in mind that the colors and values of the objects are reflected in an opposing manner (e.g., dark colors at the top of the object will appear at the bottom of the reflected image).

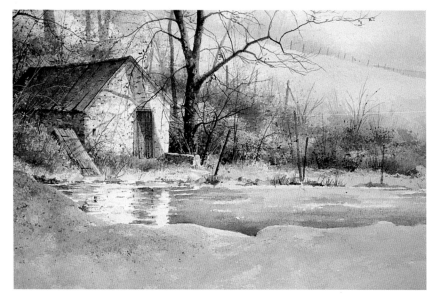

STEP 3

Apply More Foreground Reflections

Brush in the lightest value of the reflected foreground, following the squiggly line edges of the building and again leaving some unpainted streaks. While this wash is still damp, float in some of the darker colors to echo those of the real images. Remember that the colors and values are reflected in an opposing manner.

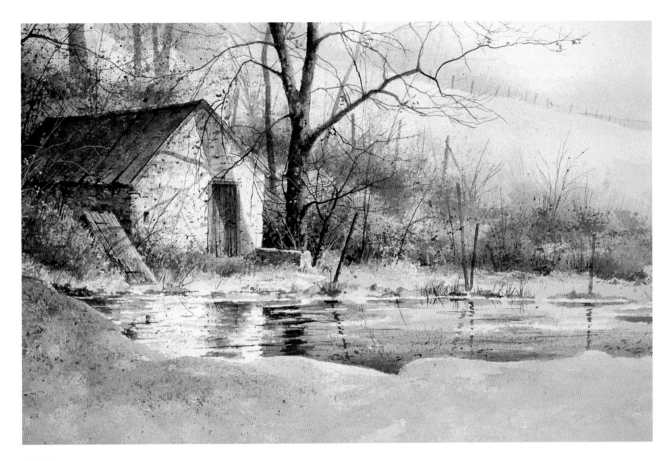

STEP 4

Add Final Details

Now add the dark values of the shoreline formations and grasses. Paint the tree and fencepost reflections with broken, squiggly lines, avoiding the white streaks left from previous applications. Finish with a few dark, horizontal streaks and a bit of spatter. Now remove the frisket. If you want to, scratch with the corner of a razor blade to add additional white streaks. This is an autumn scene, so a few leaves floating in the water seem appropriate.

Reflections, Another Example

This was one of my more successful "reflections" paintings. It has been reproduced in limited edition prints and has been the recipient of a number of national awards.

Millpond Reflections
17" × 29½" (43cm × 75cm)
Watercolor
Courtesy, Primrose Press

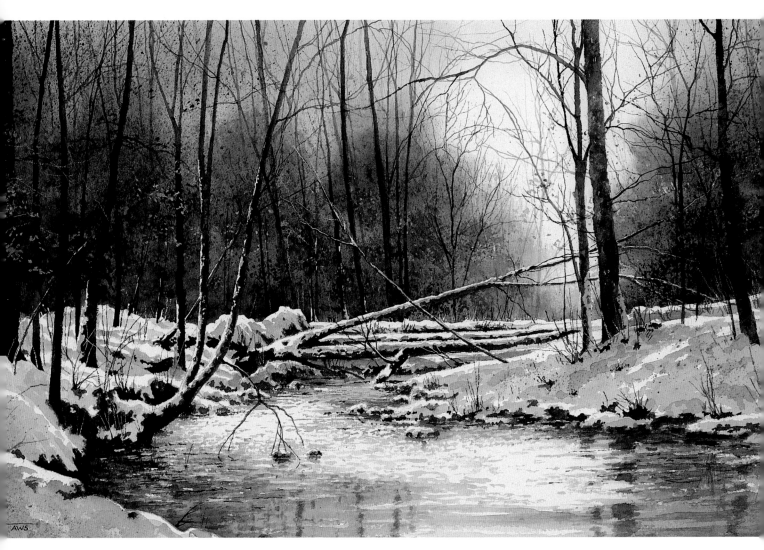

This beautiful little stream is a short distance from my home. The scene is picturesque during any season of the year, but in winter, just after a freshly fallen snow, it becomes a wonderland. The fallen trees, which add a few horizontal elements to offset the strong verticals, were of particular interest to me. A few diagonals add to the compositional variety. I began this illustration by painting the background trees using methods described in the "Background Trees" exercise on pages 28 and 29. Rather than be redundant, I will skip directly to the real subject of this exercise, which is painting the cold, icy stream in *Perkiomen Winter*.

Perkiomen Winter
13″ × 21½″ (33cm × 55cm)
Watercolor

TECHNIQUES USED:

- Masking
- Spattering

COLORS USED:

- Neutral Tint
- Warm Sepia

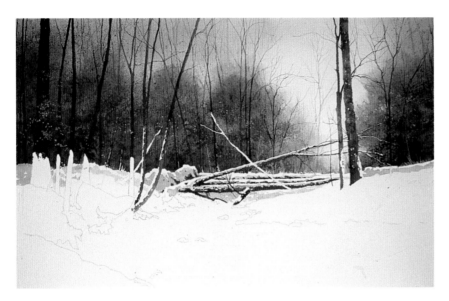

Drawing, Frisket, Background and Focal Point

Make a sketchy drawing to identify the positions and shapes of the snow clumps on the banks and the fallen trees that span the stream. Apply liquid frisket to the trees and to the area where the foreground meets the background. Complete the background work and remove the frisket. Now you need to establish the focal point, which is, in this case, the fallen timbers. With a mid-value Neutral Tint, paint the shadowed side of the snow in the middle ground. Avoid painting the top edges of the snow forms laying on the trees, as well as the snow forms on the ground, in order to allow the white paper to provide your highlights. Allow this to dry. Finish the timbers by painting the underside of their branches with Warm Sepia. Be careful to leave a thin ribbon of gray shadow between the dark value and the white-paper highlight. As a result, you have three distinct values—the white-paper highlights, the gray, shadowed side of the snow and the dark bare tree bark.

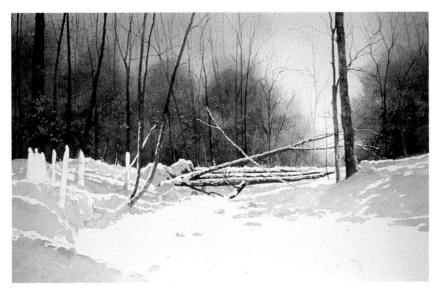

STEP 2

Define the Foreground Snow Values

Now that the lightest, mid-range and darkest values are established, use the same three values for the remainder of the foreground snow. Use a mid-value Neutral Tint to define the shadow shapes. Leave irregular streaks of white paper to indicate highlighted areas. Make a variety of rounded snow clumps along the stream with Neutral Tint to give the feeling of snow draped over uneven terrain. When this application is dry, add deeper shadows with the same gray to give some dimension to the clumps. Add spatters to the immediate foreground. Let dry.

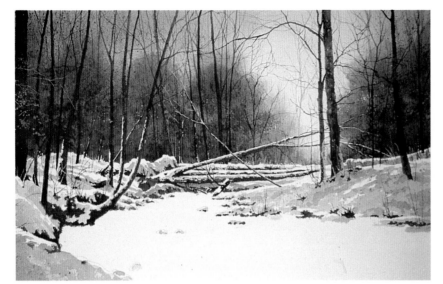

Now Put in the Darks

Paint the earthen underside of the snow clumps, the stream banks and the trees using a deep value of Warm Sepia. With your liner brush, paint some fine underbrush emanating from the dark earthen areas.

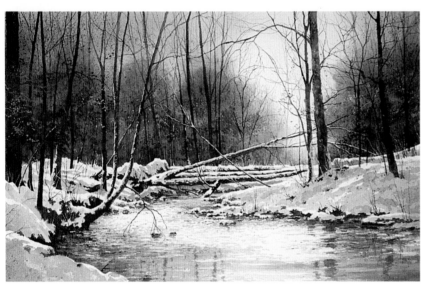

STEP 4
Tackle the Water and Ice

Clearly define two distinctly different water surfaces: the rippled surface of rushing water and the smooth, glassy surface of frozen water. Begin in the area just beneath the fallen timbers with a wash of Neutral Tint. Work forward from this point by using the same color in short, interrupted horizontal strokes to suggest ripples. As you approach the immediate foreground, use a continuous wash of Neutral Tint and Warm Sepia, leaving a few white highlights. Allow to dry. Then work back into the smooth washes with a darker value of the same colors to indicate reflections. Add the tree reflections using a lost-and-found approach and add a few white highlights, scratching with a razor blade or with white opaque gouache.

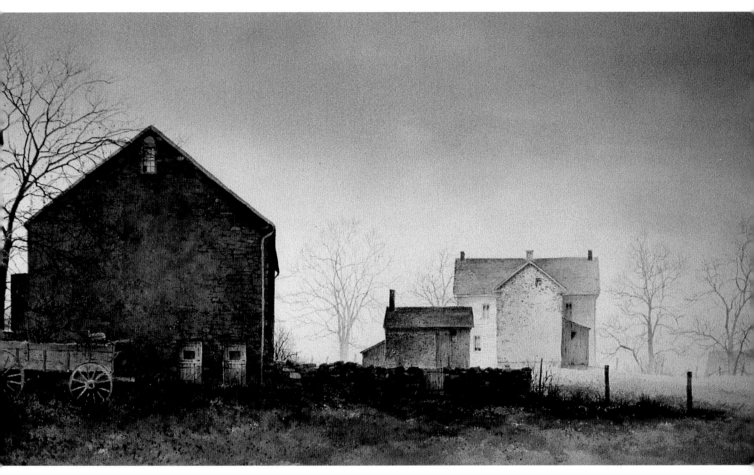

The best way to produce the feeling of depth and distance in a landscape painting is through the use of aerial perspective. The secret, reduced to its simplest terms, is to create several layers of varying intensity. The objects in the far distance are extremely blue-gray and pale, while closer objects increasingly become more sharply defined and stronger in color and value. In *Pennsylvania German*, I've created three distinct layers: (1) the background trees and building; (2) the house and surrounding outbuildings; and (3) the entire foreground. Working from back to front, each layer was completed and allowed to dry before moving on to the next.

Pennsylvania German
21¾″ × 39½″ (55cm × 100cm)
Watercolor

TECHNIQUES USED:
- Fan Brush Work
- Spattering
- Patting
- Paint and Blot

COLORS USED:
- Neutral Tint
- Raw Umber
- Raw Sienna
- Payne's Gray
- Burnt Umber
- Warm Sepia
- Sap Green
- Acryla Sepia gouache

STEP 1

Apply the First Layer

After completing the drawing, I masked off the foreground objects in preparation for painting the sky. This isn't necessary when successive layers will be darker; it's a procedure I've become accustomed to, but one that you may want to skip. Neutral Tint is an atmospheric color and will do well for the sky and far distant trees. Mix up a large, fluid batch of Neutral Tint and warm it with a bit of Burnt Umber. Apply a graduated wash for the sky, blending into clear water near the horizon. Allow to dry. Paint the distant tree shapes, the fence and the building with the same Neutral Tint/Burnt Umber mix. This completes the first layer.

STEP 2

Paint the Middle Ground

The middle ground requires a little more color and intensity. Using various combinations of Neutral Tint and Burnt Umber in a slightly darker value than before, paint the house and outbuilding. Don't include too much contrast or detail because the objects are still a good distance away from the viewer. The outbuilding is closer than the house, so it can be a little darker.

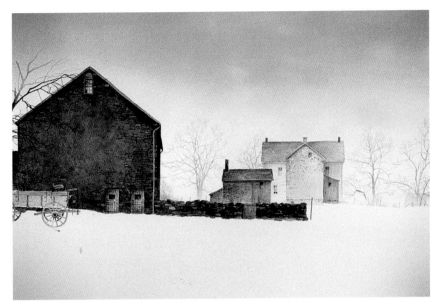

STEP 3

Wash in Barn and Stones

Wash in the barn and wall shapes using various mixtures of Raw Sienna, Warm Sepia, Burnt Umber and Payne's Gray. Allow to dry. These crude stone walls, or stone rows, as they are called, are constructed of fieldstone, laid up in a dry construction manner, without any mortar between the stones. Therefore the painting interpretation of this type of fieldstone is somewhat different. Using your liner brush, outline the stones with Acryla Sepia gouache. Then give the entire stone area a uniform wash. Paint selected stones with deeper values. A few light and dark spatters finish the job.

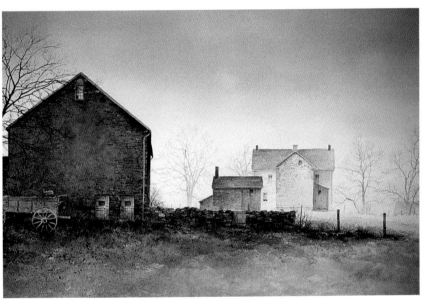

STEP 4

Complete the Foreground

Continue to work in deep shades of browns and greens to complete the wagon and the ground vegetation in the foreground. The foreground tree is saturated in Sepia to silhouette it against the sky. Now sit back and critique your work. Have you created the illusion of distance with your exercise?

Another Example of Aerial Perspective: Fog and Mist

Painting fog or mist is closely related to creating aerial perspective. Again, paint in atmospheric layers, beginning with diluted colors and values in the distance and increasing the intensity as you move toward the foreground. One more factor is added to the equation when painting fog or mist: visibility, or the lack thereof. Fog or mist reduces images to their simplest form, blurring and fusing the details to an almost monochromatic state except for hints of color in the objects closest to the viewer.

A wet-in-wet process was used to paint *A Gray Day at Valley Forge*. The predominant color is a yellowish gray, the pea-soup color of fog (Davy's Gray is a good choice for the base color). The distant background hill and trees were painted while the sky wash was still damp, which resulted in blurred edges. The forms in the middle ground were painted while there was still some dampness in the paper, but very little water was used in the paint mixture. This still produced slightly blurred edges, but the images are a little darker in value. As you move forward, the paper begins to dry and the edges of the objects become sharper and more distinct and begin to take on some color and value. The darkest images in the immediate foreground tend to "push back" the lighter areas, creating the illusion of distance. Throughout the painting, the images are blended out to nearly white at their bases to indicate the presence of ground fog.

Note: To avoid disastrous backwashes, or "blooms," carefully control the amount of water you use when applying wet colors to partially dried surfaces.

A Gray Day at Valley Forge
18½″ × 29½″ (47cm × 75cm)
Watercolor

I hate to admit it, but once in a while we artists can learn a lesson from photographers. Have you ever noticed a photograph in which a foreground object seems to jump out, almost in three-dimension, when the background is out of focus? This is due to a phenomenon known as "depth of field." The blurred background makes everything recede, allowing the more distinct subject to stand out in contrast. I achieved this result in my painting, *Mom's Althea*. I used a rough-surface watercolor paper for this exercise because it's more absorbent than the usual cold-pressed paper. Therefore, it stays wet longer during the wet-in-wet application and it encourages blending and soft edges.

Mom's Althea
14" × 21½" (36cm × 55cm)
Watercolor
Finalist, *The Artist's Magazine* competition, 1993

TECHNIQUES USED:
• Masking
• Salting
• Spattering
• Patting

COLORS USED:
• Sap Green
• Raw Sienna
• Burnt Sienna
• Burnt Umber
• Warm Sepia
• Winsor Blue

STEP 1

Drawing, Masking, Washes and Salt

Draw only the foreground items in your initial sketch; don't include background details. You want to apply loose, flowing applications without the restraint of a drawing. Mask off the flowers and foreground stems and leaves. When the masking is dry, wet the entire paper. While the paper is soaking, prepare puddles of greens, blues and browns on your palette. When the paper starts to lose its sheen, apply patches of blue for the sky and follow wet-in-wet with shapes of greens and browns. The initial shapes blend and fuse into one another due to the wet paper. Create contrast by placing darker values around an area that will have a lighter foreground object and vice versa. Sprinkle a little salt on a few of these semi-wet areas to add a light texture resembling leaf shapes.

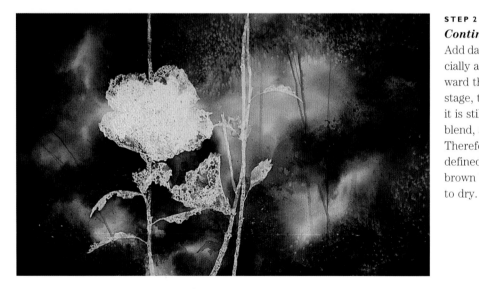

STEP 2

Continue to Refine the Background

Add darker values in certain areas, especially around the flower shapes and toward the edges of the painting. At this stage, the paper is beginning to dry, but it is still wet enough for the paint to blend, although not as fluidly as before. Therefore, your strokes will have more defined edges. Add a few gray and light brown branches in the sky areas. Allow to dry.

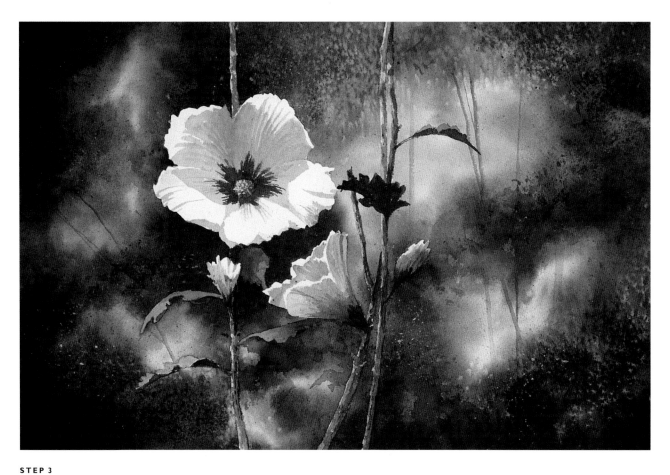

STEP 3

Texture Techniques and Foreground Objects

Get out your spattering brush to add a few dark and light spatters, and if the spirit moves you, throw in a bit of texture using the fan brush patting method on page 21. Allow to dry, and remove the masking fluid with masking tape or a rubber cement pickup. I prefer the masking tape because the cement pickup acts as an eraser and may remove part of your drawing. Remember, the paper must be thoroughly dry to even attempt this. Finish by painting your foreground objects. Strengthen the values around the flowers, if needed, to create more contrast and to increase the illusion of dimension.

Change the Mood

All too often, when you find a subject you'd like to paint, you're influenced by conditions that exist at the time. This can lead to bland, uninteresting results. Don't lock yourself in by what you see in front of you. Learn to use your imagination and exercise your creative abilities. Think of how the scene might have a more dramatic impact by changing the season, the time of day or perhaps the arrangement of objects. For example, I painted the same landscape in three different moods: (1) a cheerful, bright autumn morning; (2) a chilly, blustery winter storm; and (3) a mysterious, moonlit evening. Create some of your own moods; experiment with the reflections of a rainy day or the indefinite shapes of a dense, foggy morning. The point is, you're in charge of the world before you. Use that artistic license to your advantage to produce the best possible product you can . . . THINK MOOD.

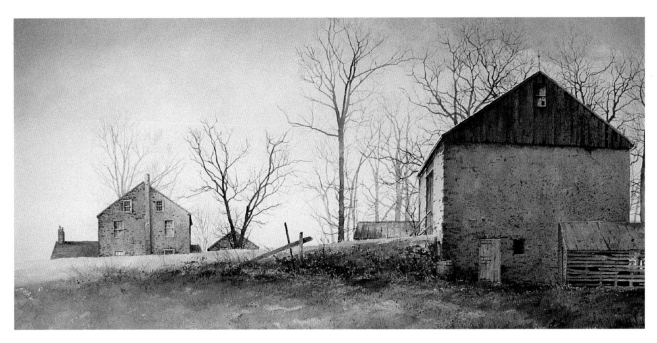

Morning at Long Farm
18″×37″ (46cm×94cm)
Watercolor

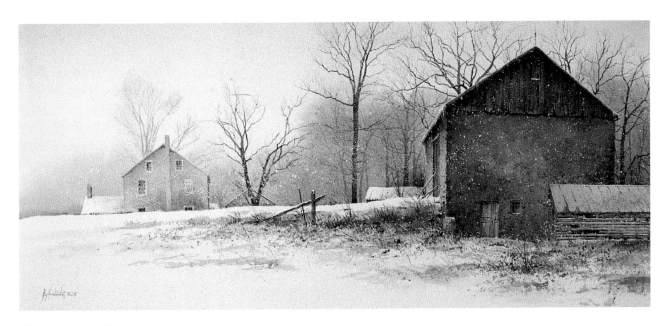

Winter at Long Farm
18″×37″ (46cm×94cm)
Watercolor

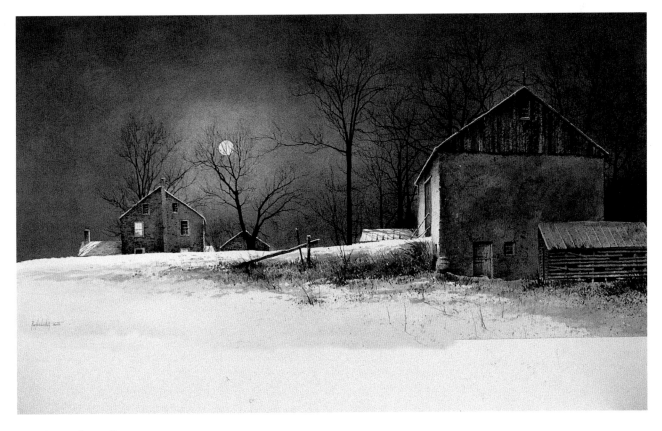

Evening at Long Farm
18″×37″ (46cm×94cm)
Watercolor

Put It All Together

Finally, we've reached the culmination of our efforts. In this chapter you'll see, in step-by-step demonstrations, the many possibilities for textural and special effects you've learned in previous chapters to come together in a finished painting. Notice that the same procedures used in various combinations result in a wide variety of effects applicable to many types of subject matter. I am sure that, through experimentation, you will discover even more applications for these procedures. I do not intend for you to copy my paintings, but encourage you to develop your own ways of working as an artist. You may choose to paint along with the book for *learning purposes only*, but it is not your own if you copy directly from someone else's work.

The Overhang
13½″ × 27″ (34cm × 69cm)
Watercolor

The contrast of a white, moonlit mantle of freshly fallen snow and the dark, looming hill in the background inspired the painting, *Chester County Winter*. Many of the texturing procedures discussed earlier in the book were used for the trees and buildings in this painting. So here's your chance to see it all come together.

Chester County Winter
19″ × 29″ (48cm × 74cm)
Watercolor

COLORS USED:

- Yellow Ochre
- Raw Sienna
- Raw Umber
- Burnt Sienna
- Burnt Umber
- Payne's Gray
- Alizarin Crimson
- Winsor Blue
- Acryla Sepia gouache
- Acryla Titanium White gouache

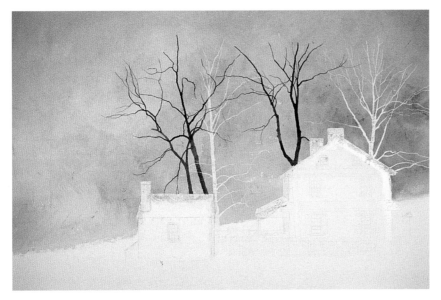

Begin the Background

I begin with a pencil sketch. The tree shapes are important to this composition, so I'm sure to sketch them in detail. I mask the two light trees with liquid frisket and paint the dark trees with Acryla Sepia gouache. This will protect the trees during the painting of the background hill. I wash in the hill using various shades of brown (Warm Sepia, Burnt Umber and Payne's Gray), leaving room for just a bit of Payne's Gray sky in the upper left corner. I added the brighter red-brown color (a mix of Burnt Sienna and Burnt Umber) near the house to draw more attention to this area.

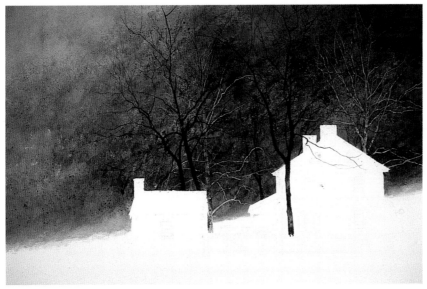

Complete the Background

Using the same background colors, I further define the textures of the hill with a combination of spatters, splatters and patting strokes using Warm Sepia and Payne's Gray. When satisfied with the textures and the value intensity, I allow the background to dry and remove the frisket. I paint the light trees with diluted Warm Sepia and Payne's Gray and add a few lighter, opaque dots with Raw Sienna, Burnt Sienna and Yellow Ochre mixed with Acryla Titanium White to indicate a few leaves still hanging on the trees. Another dark spatter of Warm Sepia finishes the hill.

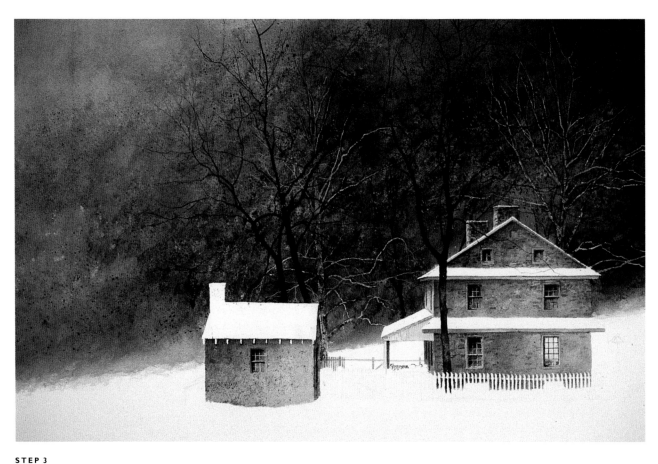

STEP 3

Paint the Buildings

I applied liquid frisket to the fence and the smokehouse rafters. I used a drawing pen to apply frisket to the mullions of the darkened windows, applying frisket to the entire window area of the lit window.

When I applied the initial washes to the buildings, I used a gradation of colors from warm (Warm Sepia and Raw Umber) on the left to cool (Payne's Gray, Burnt Umber, Winsor Blue) on the right, which is a common practice of mine. There's no need to paint every stone; an indication of a few here and there is enough to produce the desired effect. I painted the dark windows with Warm Sepia and then the lit window with a light Yellow Ochre, starting lighter at the top and gradually getting darker with Raw Sienna at the bottom. I followed by painting the window mullions. A few spatters of Warm Sepia here and there, to increase the feeling of roughness, finish the job.

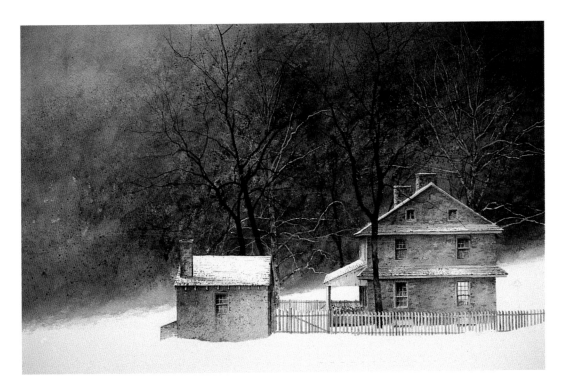

STEP 4
Add the Building Details
When the previous work was completely dry, I removed the frisket and painted the smokehouse rafters. I painted the brick chimney with Winsor Blue and Payne's Gray and added a few red bricks with Alizarin Crimson and Burnt Sienna. If the shadows just under the roofs needed strengthening, I hit this area with a darker value of Warm Sepia. I used a spattering-and-lining technique to simulate snow-covered shingles on the roofs. I then added the woodpile on the porch.

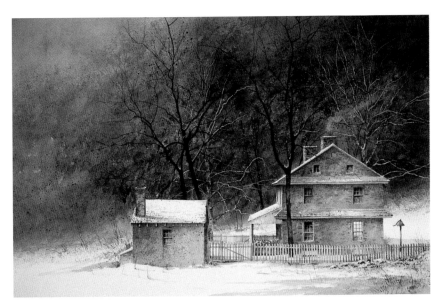

STEP 5
Paint the Foreground
I added a few Payne's Gray shadows and Warm Sepia weeds, including some opaque Acryla Titanium White weeds. I added the Warm Sepia rockpile for additional interest. A couple of finishing touches—the Warm Sepia dinner bell in the backyard and the Acryla Titanium White smoke rising from the chimney—indicate a human presence and complete the painting.

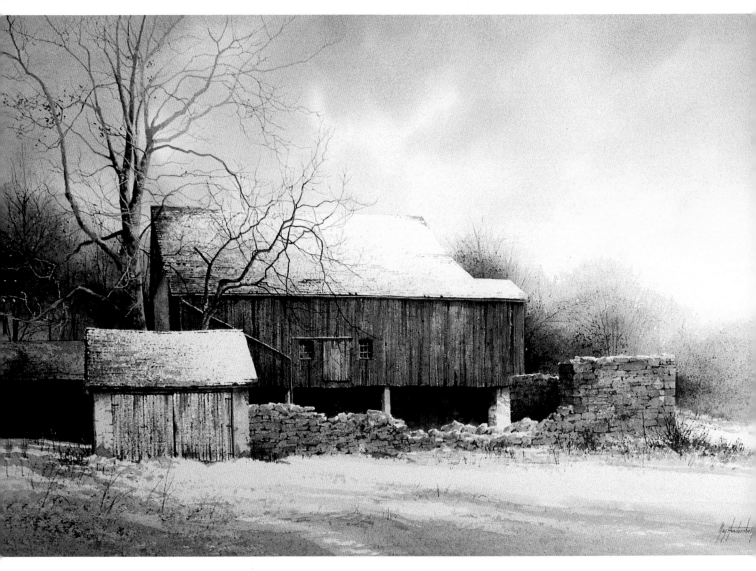

I've painted this old barn with its adjoining carriage house and crumbling wall on numerous occasions. It has the perfect balance of textures for my tastes. In this painting, the two large trees on the left become a major compositional link that ties all of the other elements together, so give special attention to their structure.

Carriage House
18″ × 29½″ (46cm × 75cm)
Watercolor

COLORS USED:
- Yellow Ochre
- Raw Sienna
- Raw Umber
- Burnt Umber
- Burnt Sienna
- Warm Sepia
- Payne's Gray
- Winsor Blue
- Acryla Titanium
 White gouache

Detailed Pencil Sketch and Sky

Any major painting such as this begins with a fairly detailed pencil sketch. I do about 95 percent of my planning at this stage so I have a good idea of the finished product before putting brush to paper. Usually, only minor changes are made during the painting process, allowing, of course, for those happy accidents that frequently occur during the execution of a watercolor painting. At this point, I completely mask off the foreground buildings to allow as much freedom as possible while painting the sky and background. When the liquid frisket dries, I thoroughly wet the sky area. After the water soaks in a bit and the paper begins to lose its sheen, I lay in the sky wash, beginning with a pale Raw Sienna near the horizon and graduating into patches of warm Payne's Gray, Burnt Umber and Winsor Blue at the top. If the correct amount of moisture is left in the paper, the colors will blend and fuse to make a pleasant, clouded sky. I help this blending process by propping up one end of the painting board about two inches at the top to facilitate the flowing of the washes. I let this stage dry.

STEP 2

Paint the Background Trees

I mask off the lower trunk and branches of the main trees and paint the background wooded area with Warm Sepia and Payne's Gray. I covered the sky with a towel to protect it from spatters of paint. Various browns (Warm Sepia, Burnt Umber, Payne's Gray) fade into grays at the top and far distance. I spattered some dark Warm Sepia leaf masses and painted the background tree trunks and limbs. I indicated a few light leaves using Yellow Ochre and Burnt Sienna mixed with Acryla Titanium White gouache.

Begin to Paint the Barn

Now, with the masking on the large trees still in place, I began to paint the barn. I painted a wash of Payne's Gray warmed with Burnt Umber over the entire barn front and let it dry. I masked the door and windows and used the dry-brush and spattering techniques from the exercise "Weathered Barnwood" on pages 47-49 to create the look of aging wood siding with a deeper mix of Payne's Gray and Burnt Umber. After this phase was dry, I removed the masking from the doors and windows and remasked the window frames and mullions. I applied the frisket with my crow quill pen. I roughened the boards on the doors with a dry-brush technique and painted the dark Warm Sepia window panes, finally removing the masking to expose the window structure. I then rendered the far left end of the barn, being careful to place dark values adjacent to light background areas and vice versa.

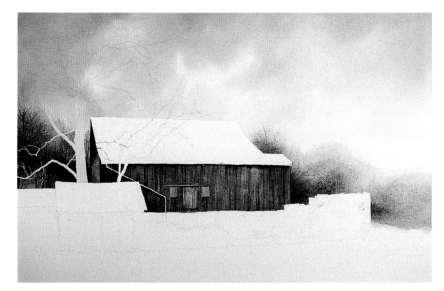

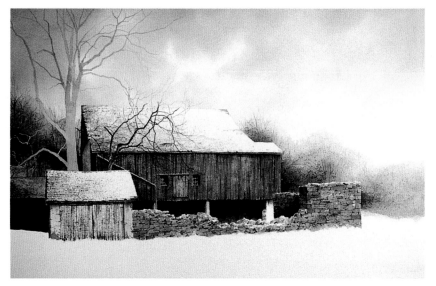

STEP 4

Carriage House, Background Building and Wall

I used the dry-brush techniques from step 3 to paint the carriage house with Payne's Gray and Burnt Umber. Vertical streaks of Yellow Ochre and Burnt Sienna suggest the peeling paint of the aging wood doors. I painted the background building with deeper values of Burnt Umber and Payne's Gray to act as a foil for the lighter building in front, giving the illusion of depth.

For the crumbling stone wall, I painted a variegated wash of browns and grays (Payne's Gray, Burnt Umber, Warm Sepia, Raw Umber), skipping the areas where snow accumulates (these areas may be masked off before the wash if you don't feel comfortable painting around them). Then I painted the divisions between the stones with a very dark value of Warm Sepia. Don't be too precise by painting every line. A lost-and-found approach is much more convincing. Now add the shadows on the right side of the wall with a deeper version of the above wall wash.

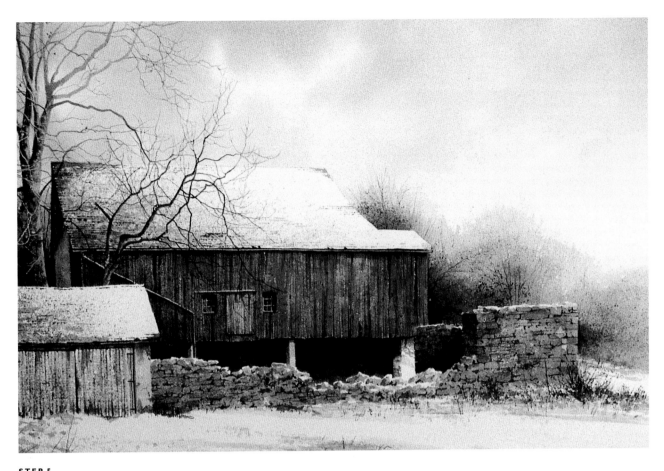

STEP 5

Paint the Rooftops, Trees and Foreground

The snow-covered rooftops are next on the agenda. I've found that splattering is the best way to suggest the irregularity of snow lying on top of a shingled roof. I began with the barn roof. First, shield the areas surrounding the roof with file cards or masking tape. Mix up a batch of snow color (in this case, Payne's Gray and a little Warm Sepia) and, using one of your bristle brushes, begin to splatter, concentrating primarily on the left end of the roof. Follow with a splatter of water to create a variety of dot sizes and shapes. After this application is dry, draw the shingle divisions with wavy lines of dark Warm Sepia. Indicate where the snow has blown off the roof, exposing the darker color of the roof, with this same brown. Now, using the same procedures and colors, I painted the carriage house roof.

Next I painted the two tree shapes entirely with a wash of Payne's Gray and Warm Sepia. I followed this by overpainting with Warm Sepia on the left side (the side farthest from the light source) of the branches. The smallest tree and the branches that extend to the rear of the largest tree are painted entirely in Warm Sepia. I used the same gray-brown mix (Payne's Gray and Warm Sepia) to paint the shadows in the foreground snow. Finally, I added a few dark weeds with a liner brush and Warm Sepia.

The fading colors of autumn's brilliance take a final bow in this almost abstract composition. The object of this painting was to capture the depth of the water and to make the colorful, floating leaves appear to come forward, toward the viewer. *Last Shades of Autumn* presents some interesting painting techniques you may want to consider for your future endeavors.

Last Shades of Autumn
19″×29½″ (48cm×75cm)
Watercolor

COLORS USED:
- Burnt Sienna
- Burnt Umber
- Payne's Gray
- Warm Sepia
- Raw Umber
- Raw Sienna
- Cadmium Yellow
- Cadmium Red
- Sap Green
- Acryla Titanium White gouache

Drawing and Stream Floor Wash

A very precise drawing is necessary to establish the shape and position of the leaves. Next, I carefully masked the leaf shapes with liquid frisket. I began by laying a loose wash of Burnt Sienna and Burnt Umber over the entire paper to represent the base color of the submerged leaves on the stream floor. I added acrylic matte medium to this wash to make it less susceptible to lifting during the next step. I also graduated the wash from light to dark, upper right to bottom left. I don't worry about imperfections in this wash because most of it will be hidden during subsequent applications.

STEP 2

Define the Submerged Leaves

I established the final color and value of the water and defined the underwater leaves. Hopefully, by keeping these shapes indistinct, they'll be "pushed back," creating the illusion of depth. I used a paint-and-blot technique to create these shapes. While the first wash was still wet, I laid in a darker second wash of Burnt Umber and Payne's Gray, blotting this occasionally with a damp, crumpled paper towel, lifting the dark color of the second wash to reveal obscure shapes underneath. I scratched a few "sticks" using my fingernails.

STEP 3

Texture the Stream Bed

After the previous work was thoroughly dry, I textured the stream bed with a few dark spatters of Warm Sepia and followed with some Acryla Titanium White spatters, particularly in the lower right corner. The white specks give an illusion of surface activity on the water. I also added a couple of bubbles by applying larger drops of Titanium White gouache, allowing a few seconds drying time and then blotting them with a paper towel. This technique removes most of the paint from the center of the drop, leaving a distinct white ring that suggests a bubble. After drying, I removed all of the frisket.

STEP 4

Paint the Surface Leaves

I painted the surface leaves using various blends of Raw Sienna, Sap Green, Burnt Sienna, Burnt Umber, Cadmium Yellow and Cadmium Red, painting each individual leaf wet-in-wet so that the color freely blends. I was not concerned with details at this point; I merely established a pleasing blend of colors while varying darks and lights. I added some shadows where leaves overlap or where their edges turn up.

STEP 5

Add the Final Touches

I continued to refine the leaf colors and shapes. I added splotches of contrasting colors to some of the leaves and to a few darker areas (with darker versions of the same color) to suggest that part of the leaf is beneath the water. I added details such as leaf veins and insect holes for realism. A few spatters contributed a rustic touch. My final evaluation was that additional white spatters and sticks were needed to liven up a couple of the dark, empty areas between some leaf groups. When finished, I was pleased with the suggestion of depth and with the overall abstract composition of the painting.

The first time I saw this beautifully carved, antique rooster, I knew I had to include it in a painting. When choosing other elements for the picture, I couldn't resist including the eggs. The sharply angled lighting caused an interesting shadow pattern that became a perfect foil for the white eggs and eggcup. All in all, this composition presents an interesting painting challenge because it requires several types of texture techniques. Give it a try.

Standing Guard
15″ × 29½″ (38cm × 75cm)
Watercolor

COLORS USED:
- Raw Umber
- Payne's Gray
- Winsor Blue
- Raw Sienna
- Burnt Umber
- Alizarin Crimson
- Cadmium Yellow Medium
- Burnt Sienna
- Cerulean Blue
- Acryla Sepia gouache

STEP 1

Paint the Wainscoted Background

I began with a detailed drawing. There are only a few pure whites to save. I applied liquid frisket to the eggs, the eggcup, the nailhead, the knobs on the spice cabinet, the label on the shelf and the glint in the rooster's eye. After the frisket dried, I gave the entire paper an even wash of very pale yellow (Raw Umber). This gives an overall uniform glow to the painting. After drying again, I was ready for a second application of frisket, this time masking all the surfaces that catch the light source coming from the upper left. This includes the left side of the cabinet, the top surface of the shelf, the top surface of the rooster base and a thin line at the left edge of each board in the wainscoting. Then I applied a second wash of diluted Raw Umber and allowed it to dry. I defined the beaded areas

between the boards with a slightly darker value and accented the right edge of each board with a thin, dark line. In preparation for the shading and texturing of the background, I applied a third application of frisket. This time, I masked the entire rooster and the remainder of the cabinet and shelf. Then I began shading, using light values and shades of Raw Sienna on the upper left and dark values and shades of Cerulean Blue on the lower right and under the shelf. I added the shadow cast by the rooster and allowed it to blend into the dark shading on the right. I added blotches of Raw Sienna to suggest areas of peeling paint. I further defined this effect by drawing lines using Raw Umber and a crow quill pen. I added a few spatters to age the wood and removed all of the frisket.

STEP 2

Paint the Rooster

There are a number of areas on the rooster where the paint is peeling or worn. These areas can either be masked with frisket, or you can paint around them as I did to minimize hard edges. I masked the eye and painted the face and comb with Burnt Sienna and Alizarin Crimson, gradating the wash to a darker value by adding Warm Sepia on the shadowed (right) side. I removed the frisket and painted the eye, leaving a spot for a white highlight in the left center. I painted the neck with a wet-in-wet application of Raw Sienna and Winsor Blue to allow for shading. I continued with the breast and body (primarily Burnt Sienna and Alizarin) and tail feathers (Raw Sienna and Burnt Umber), painting in flat washes and defining the feather outlines with watercolor and a crow quill pen. The last stage was to paint the base with Cerulean Blue and Raw Sienna and apply a few spatters for an aged appearance.

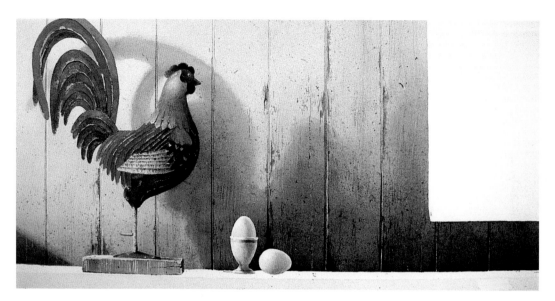

STEP 3

Wet-in-Wet Eggs and Eggcup

With all the roughness in the rest of the painting, the eggs provide relief with their smooth, translucent quality. This painting was done totally in a wet-in-wet manner to allow for smooth tonal and color transitions. I wet the paper within the egg shape and sponged off the surface water. I applied a muted wash of Payne's Gray and Warm Sepia to the entire egg, avoiding the highlight on the upper left. I followed with a deeper,

warmer gray on the shadowed side and blended it into yellow (Raw Sienna) on the extreme right and bottom, to give the appearance of reflected light. I completed the eggcup the same way, except I masked off the sharp highlight first. I added the Winsor Blue bands, getting progressively darker on the shadowed side by adding Warm Sepia.

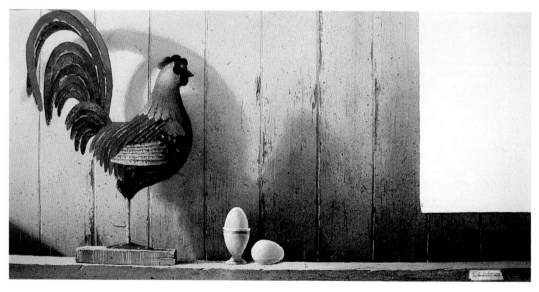

STEP 4

Paint the Shelf

After remasking the label, I applied a wash to the shelf edge. There's no need to produce a perfectly straight line between the edge and the surface of the shelf. In fact, the shelf will look more rustic and distressed if the line is uneven. I shaded the shelf wash, graduating from warm colors (Burnt Umber, Burnt Sienna) on the left (the light source) to cooler tones (Burnt Umber, Winsor Blue) on the right. When this was dry, I laid a similar wash on the top of the shelf, but used diluted values. I

added a few cracks, a suggestion of wood grain, some distress marks in deeper values of the same colors and a few spatters. These were highlighted by scratching on the right and bottom sides of the marks with the corner of a razor blade. I added shadows (Burnt Umber and Winsor Blue) on the shelftop, just to the right of the rooster base and the eggs. I finished by painting the detail on the label with Cadmium Red.

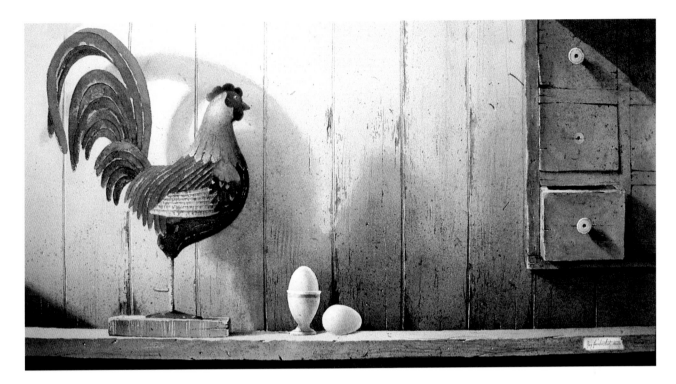

STEP 5

Spice Cabinet and Shadows

This was painted using the same techniques described in an earlier exercise on pages 50-52. I masked the left side of the cabinet, the knobs, the bare spot indicating a missing knob, and the top of the open drawer with frisket. I painted the major part of the cabinet with a mix of Winsor Blue, Burnt Umber and Cerulean Blue, with the worn edges done in Raw Sienna. I added the divisions between the drawers, the cracks, distress marks and spatters with concentrated Acryla Sepia gouache.

I removed the frisket and finished painting the left side of the cabinet, the open drawer and the knobs. I added the shadows cast by the open drawer and the knobs and painted the shadows underneath the cabinet. I chose to deepen the shadow under the shelf with a darker value of the same colors and to add a diagonal shadow cutting across the upper right corner. I decided this would help contain the viewer's eye and direct it back toward the center of the painting.

This is the ultimate in geometric compositions. Early one morning as I drove by this apartment building, I was struck by the intricate shadows cast by the fire escape railings. Although relatively flat in perspective, there are a number of receding and projecting planes that produce a great deal of depth to this subject. Combined with the unusual, almost abstract arrangement of windows and doors, this building is ideal for a dramatic facade painting. Because of the amount of detail, this watercolor requires a good deal of planning and preparation, but I think the result is well worth the effort.

The Apartment
19½" × 29½" (50cm × 75cm)
Watercolor

COLORS USED:
- Raw Umber
- Payne's Gray
- Warm Sepia
- Raw Sienna
- Cadmium Red Medium
- Cadmium Yellow Medium
- Winsor Blue
- Burnt Sienna
- Alizarin Crimson
- Sap Green

Paint the Railings

After making a detailed drawing, I used the darkest values to paint the railings. I chose to add acrylic medium to a dark mix of Warm Sepia and Payne's Gray. This makes it water resistant and less likely to lift later when I paint the intricate shadow patterns in close proximity to the railings. I used a straight-edged bridge as a tool to help paint the many straight lines in the railings and tried to add some dimension by using darker lines in the back and lighter lines in the front (by diluting the mix). After this dried, I masked off the window perimeters and mullions to prepare for the next step.

STEP 2

Begin the Individual Windows

Practically, each window in this composition has a unique personality. After the liquid frisket was dry, I began with the middle window at the top. I moistened the entire window area and floated in a varied wash of Payne's Gray and Raw Umber, again letting it dry. I added the dark shadow by adding Warm Sepia to the mix and again allowed it to dry. I removed the frisket and added shadows to the mullions and the window frame to give depth. The second window, in the bottom center, sports a yellow blind in the top half. I used Cadmium Yellow Medium with Raw Sienna in the shadows for this second window. The bottom half, which receives the strong shadows of the railings, was treated like the first window. I handled the remaining windows similarly. The lower right windows require vertical stripes to suggest the folds in draperies.

Paint the Door and Canopies

I painted the door using the window technique from step 2. I masked off the small details, such as the light bulb and the pot of flowers, to prepare for the fluid washes of Payne's Gray. I added the dark shadows last. Next, I painted the overhanging canopies and the shadows underneath, graduating the values from very dark (Payne's Gray, Winsor Blue, Warm Sepia) immediately under the overhang to light as I progressed downward (blended toward Raw Umber/ Warm Sepia). This gives a strong illusion of projection to the canopies. I added a thin strip of blue sky (Winsor Blue and Raw Sienna) in the upper right corner.

STEP 4

Mask Areas and Wash in Shadows

I painted some of the shadows freehand, but the patterns were so intricate on the left side of the composition that I used masking fluid to shield some of the white areas during the application of the shadow wash. This eliminates mistakes and allows a more even graded wash. I also masked some of the details, such as the electric boxes and the wires. At this stage, using the acrylic medium in the painting of the railings pays off, because I don't have to worry about picking up the dark color in my shadow wash and destroying that sharpness of line necessary to create the illusion of depth. The wash (Raw Sienna, Raw Umber, Warm Sepia) should be darker at the top and beneath the landings, becoming increasingly lighter by removing Sepia and adding water while moving away from these areas. I allowed this application to dry thoroughly.

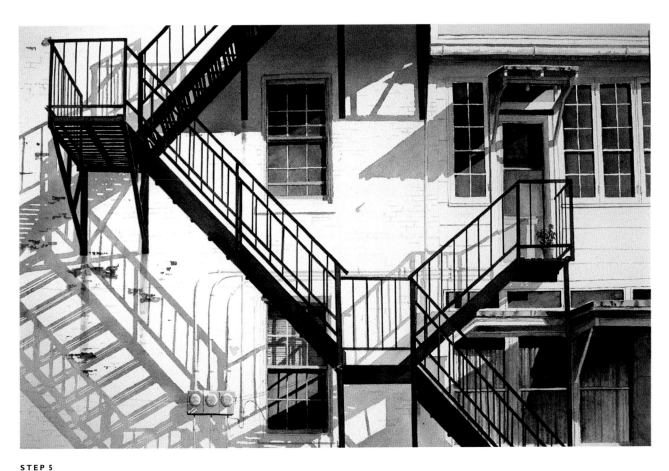

STEP 5

Add the Final Details

After removing the frisket applied in the last step, I began to add the final details. The electric boxes came first, again allowing for light and dark patterns to continue across their faces. I defined the wires by shadowing the side facing away from the source of light with Raw Sienna, Raw Umber and Warm Sepia. I added some shadows to suggest the mortar lines between the bricks. I used a lost-and-found technique to avoid overdetailing an already busy painting—just enough to break up some of the more prominent white areas. I painted the roof line and the rain gutter next. I added a few areas of brick red (Burnt Sienna and Alizarin Crimson) to indicate white paint peeling from the bricks, and finally, the *coup de grace*: a bit of color (Sap Green and Cadmium Red) in the form of a pot of geraniums on the landing.

The Portfolio

Finally, let's take a look at other examples using watercolor textures and special effects. In this portfolio, I've attempted to show a range of subject matter and painting ideas that incorporate the use of the techniques discussed in this book. Study the paintings and try to determine which methods were used in each one. Think of how you might use a similar approach on one of your own paintings or, better still, expand on these thoughts and envision new approaches that you could use to enhance your work.

Slats
16½″ × 29″ (42cm × 74cm)
Watercolor

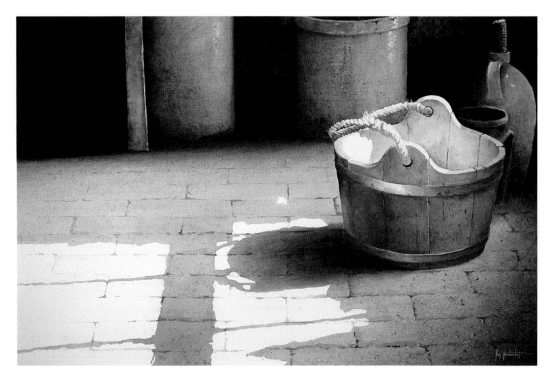

The Pantry
18½″×29″
(47cm×74cm)
Watercolor

The moment I walked into this room in a 200-year-old house in Lancaster County, Pennsylvania, I was stopped dead in my tracks by the shaft of light knifing across the cobblestone floor. This is the kind of thing from which goosebumps are made. I knew immediately that I had to paint it. This watercolor will always hold a special place in my collection because it was selected for inclusion in the American Watercolor Society exhibition and was responsible for my election into signature membership in that organization.

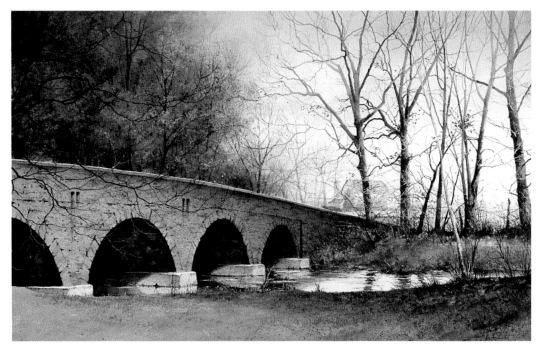

On the Way Home
18″×28½″
(46cm×72cm)
Watercolor

I passed this stone arch bridge practically every day and usually took it for granted. Then one day I decided to paint it. I was just in time, because soon after, the bridge began to crumble and had to be repaired. Unfortunately, the new renovations have robbed it of its charm. This painting provides another good example of background foliage treatment. Some of the textures are barely visible, but all contribute to the overall effectiveness.

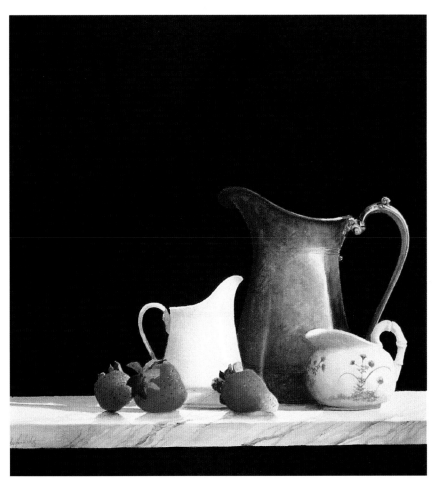

Some friends of ours loaned this pewter pitcher to me, thinking it might be a good still life subject. Coincidentally, the shape closely resembled those of a couple of cream pitchers in our own collection, and putting them together seemed to be destiny. Thanks, Fay and Frank.

I decided to eliminate background detail in this painting to focus the emphasis on the shapes. As a matter of fact, the background is solid black. But notice how nicely it sets off the foreground objects.

Three Pitchers
16″ × 14½″ (41 cm × 37 cm)
Watercolor

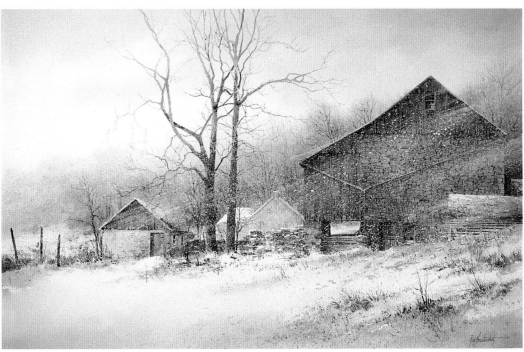

Blizzard of '93
18½″ × 29″
(47 cm × 74 cm)
Watercolor
Courtesy of
Koh-I-Noor
Corporation

Here's another of my blizzard paintings. This was done as a result of a major snowstorm in the Northeast. It gained notoriety as the subject of a how-to article I wrote for *Palette Magazine*. It also served as the cover picture for that particular issue. It hangs in a prominent place in our home because it is one of my wife's favorites.

A number of years ago, I painted a watercolor of a dogwood branch not unlike this one. My wife immediately took a shine to it. Unfortunately, it was sold at one of my one-man shows. After that, she continually reminded me that "I owed her one." Well, dear, here it is.

In this one, the complexity of the background is in sharp contrast to the simplicity of the flowers. The strong light against dark adds to the illusion of depth and dimension.

Dogwood
22¾″ × 29½″ (58cm × 75cm)
Watercolor

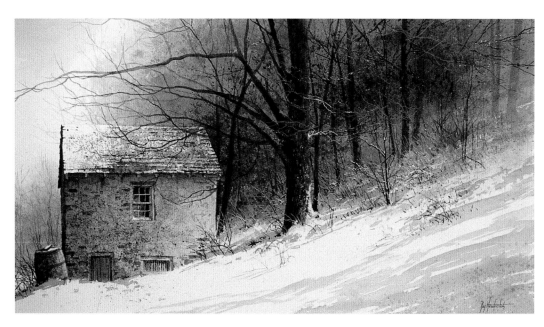

Again, strong light and dark contrasts emphasize the illusion of depth. Look how far you can see into the woods. I love these old Pennsylvanian outbuildings. They are disappearing swiftly, but fortunately, many still dot the countryside, waiting for the artist or photographer to record them for posterity. There may come a time when this might be the only way to show future generations this way of life.

Milkhouse
10½″ × 19″ (27cm × 48cm)
Watercolor

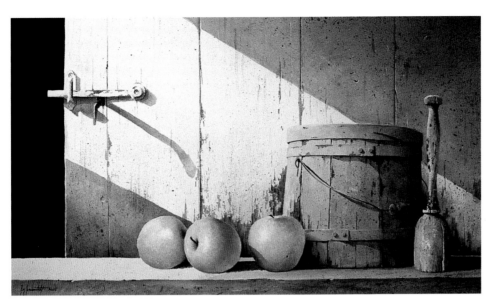

I used intense light and shadow diagonals to draw the eye into the painting and to the focal point. Dark-against-light and light-against-dark principles were used throughout this painting to emphasize the illusion of dimension.

Blue Firkin and Apples
17″ × 28½″ (43cm × 72cm)
Watercolor

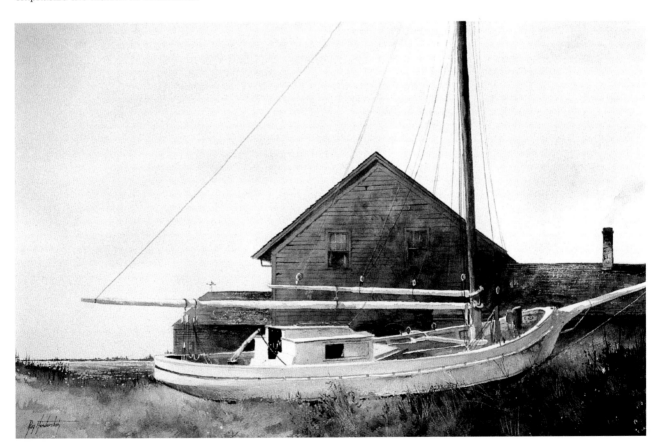

I did this little watercolor as a result of one of my trips to Maine. There's a certain feeling of permanency about the gray, unpainted clapboard buildings that dot the coastline. They look as if they could stand against the raging ocean winds forever.

Dry-docked
19½″ × 14½″ (50cm × 37cm)
Watercolor

This is another variation of how to paint background woods. In fact, in this painting, the woods actually became the main subject. The first snow of winter came at a time when many of the trees had not yet lost all of their leaves. Some color still interrupts the bland grayness of the wood.

North Gate
12½″×20″ (32cm×51cm)
Watercolor

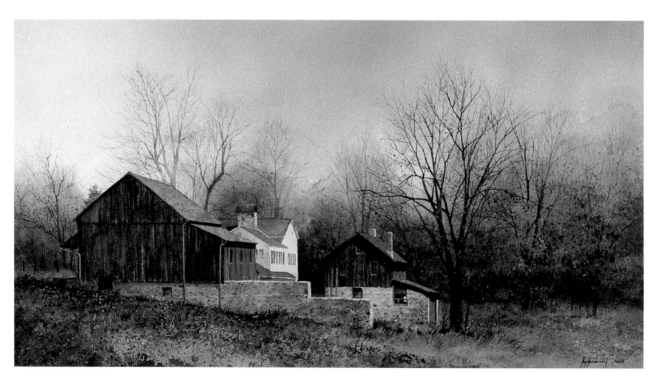

There are plenty of background woods textures here. I like the way the white house peeks around the corner of the darker foreground buildings. The scene is, as the title suggests, a farm just north of New Hope, in Bucks County, Pennsylvania. New Hope is a very picturesque area that's famous for its connection to the arts.

North of New Hope
14¾″×28½″ (37cm×72cm)
Watercolor

This small painting is one of my favorites—not because it's a great work of art, but because it's a picture of one of my father-in-law's musical instruments. I'll always think of Clem when I look at it. In this one, the entire background was spattered to suggest a stuccoed wall.

Four Stringer
8″ × 16½″ (20cm × 42cm)
Watercolor

I think this lighthouse originally was positioned over the water. It is now on dry land and is currently a tourist attraction as part of a maritime museum along Chesapeake Bay. I painted it as if it was still in service on this gray, overcast day. I hope you can feel the chill in the air as you look at it.

Blowing In
17″ × 29½″ (43cm × 75cm)
Watercolor

This was my first wagon painting in watercolor. At the time, I was a bit more loose in my treatment of background trees and foreground foliage. Although it was painted in 1974, I still feel, after all these years, that this was one of my more successful paintings.

Blue Wagon
15″×23″ (38cm×58cm)
Watercolor

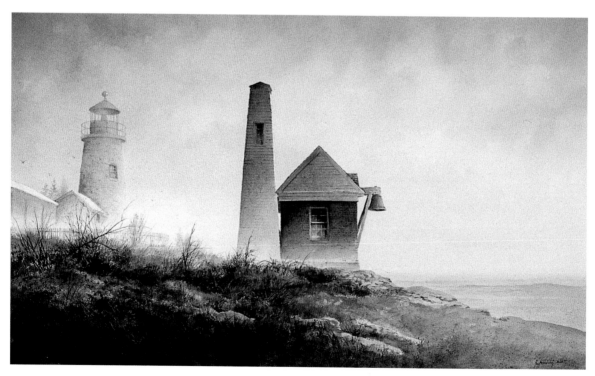

Although it looks like I spent many hours detailing the foreground, it actually was done very swiftly using my fan brush techniques. Remember to paint weed masses, not individual weeds.

The Sentinel
22″×39½″ (56cm×100cm)
Watercolor

Here's another painting that belongs in my geometric composition series. I'm amazed at how often the perfect arrangement of shapes naturally occurs. The shadows, cast by an unseen tree, provide appropriate diagonals to complement the otherwise rectangular composition. Great barnwood study.

Lattice
9¾″ × 6¾″ (25cm × 17cm)
Watercolor

Onion snow is the term given to the last snow of the year—sort of the last gasp of winter before the first signs of spring begin to show. This composition is similar to those included in the exercise "Changing the Mood." It's a particularly good example of stone and stucco textures.

Onion Snow
18″ × 37″ (46cm × 94cm)
Watercolor

The shape of this quaint little milkhouse caught my attention. How I love the stark white of a building silhouetted against a dark background. The treatment of the foliage is covered in the exercise "Fully Foliated Trees." This painting is one of my miniatures. These small paintings were originally done as thumbnail sketches for larger works, but more recently have gained respect as finished paintings that stand on their own.

Hopewell Milkhouse
5″×9½″ (13cm×24cm)
Watercolor

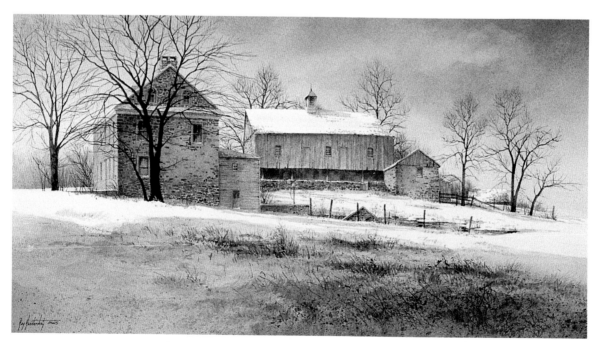

Only a few miles from my home, Oley Valley has provided me with a wealth of subject matter over the years. Each time I drive through that area, I seem to see something new—or should I say old. In this painting, a colorful sky makes the snow even whiter, and a very limited palette provides a sense of harmony in this little rural scene.

Near Oley
12¾″×23¾″ (32cm×60cm)
Watercolor

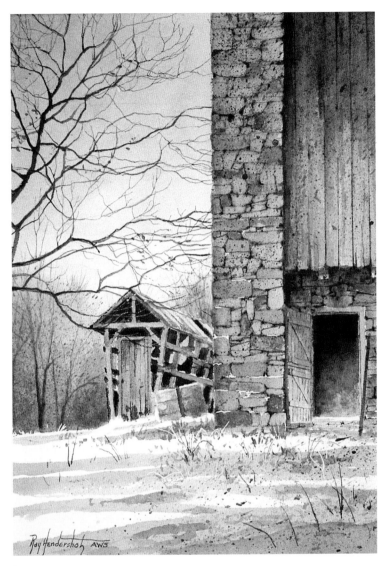

This is another of my miniatures. The great, old Pennsylvania-German bank barn in this painting was a glorious subject in its own right, but peeking around the corner, I discovered another worthy subject—a dilapidated, weathered corn crib that had seen better days. What a neat little L-shaped composition these structures made.

Around the Corner
9¾″ × 6¾″ (25cm × 17cm)
Watercolor

Heavy foreground shadows emphasize the sunlight knifing across the middle ground of this small painting, leading your eye directly to the milkhouse. The scene is at the historic Thompson-Neely house on the grounds of Washington's Crossing State Park.

Out Back
7¼″ × 13¾″ (18cm × 35cm)
Watercolor

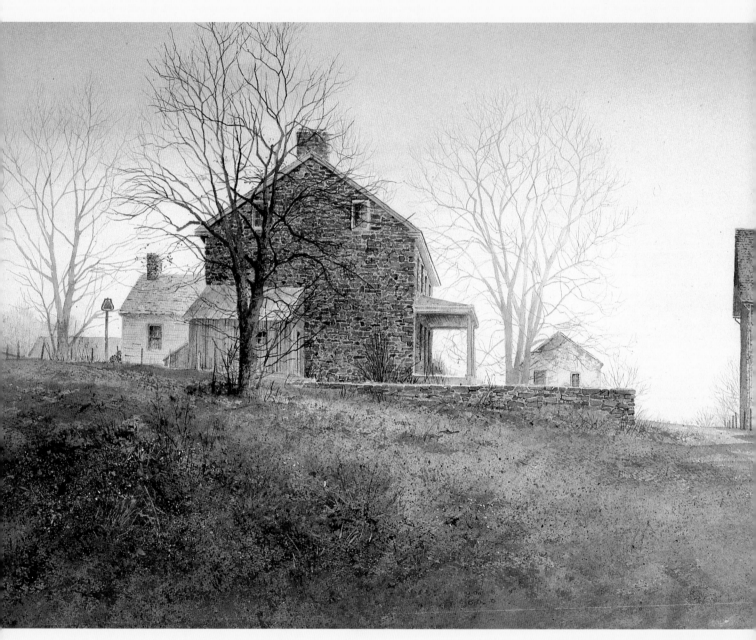

Rural Morning
18″ × 37″ (46cm × 94cm)
Watercolor

In this book you have learned new techniques for painting watercolors. In no way do I suggest that they are the correct or even the best techniques—they are merely my techniques. The nice thing about art is that it allows for personal expression. As artists, we do not have to abide by a strict set of rules. We merely observe, mentally record and use those things that we think will improve what we are already doing.

I hope I am able to provide you with a few suggestions to increase your ability to express yourself. If so, and if they are reflected in your work, I will consider my efforts to be worthwhile. All I ask in return is that, in your painting, you continue to be yourself. After all, as artists, we have the ability to express ourselves as individuals. Take advantage of the opportunity. Happy painting.

INDEX